Ursula Schulz-Dornbury
Martin Zimmermann

THE DIVISION OF THE WORLD

Ursula Schulz-Dornburg / Martin Zimmermann

THE DIVISION OF THE WORLD
On Archives, Empires and the Vanity of Borders

Translated by Henry Heitmann-Gordon

Haus Publishing

List of Contents

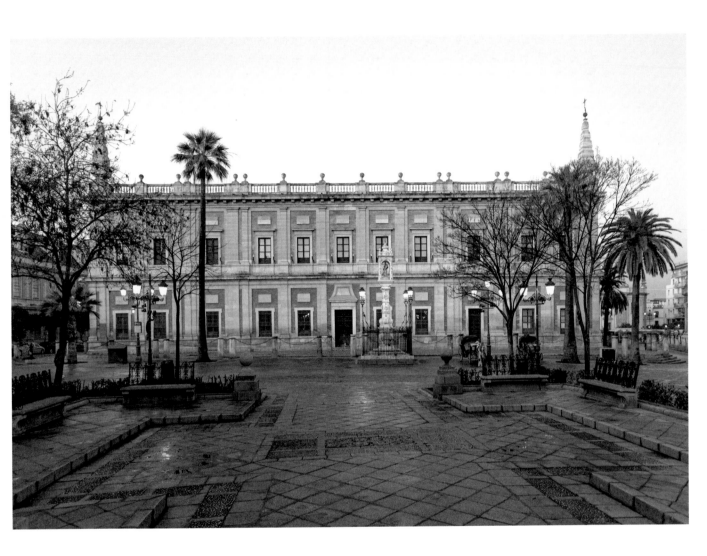

"The light is only any use at all at half four in the morning!" With these words, Ursula Schulz-Dornburg sat herself at my table for breakfast at a hotel in Jordan a few years back. She had just returned from a three-hour hike through the barren mountains surrounding the famous gorge of ancient Petra. Long before dawn, she had entrusted herself to a young Arab guide, a complete stranger, to make use of the early light to take pictures. I meanwhile had slept in, as had the rest of our small tour group. That day I, a historian of the ancient world, was to serve as the group's guide through the rock tombs and ancient settlement. With a certain envy, I listened to her stories of deep ochre mountain panoramas and the early desert light. And I was captivated by the boldness with which she had set out on an unknown path at night and by all the tales she could tell of her young guide and his hard life as a shepherd after such a short excursion.

Our first meeting was only brief. But (as I was to learn in more detail later) this little episode revealed a great deal about the courage that had propelled Schulz-Dornburg and her photo equipment through inhospitable regions of the world for many decades and the attentive and genuine interest with which she engaged with people everywhere.[1]

My personal starting point for our joint book project could therefore fairly be called—as per literary convention—an 'unexpected meeting'. In retrospect, considering what followed, I might describe that accidental, initially fleeting encounter as what the Ancient Greeks called *kairos*: a uniquely favourable, and hence consequential, moment in time. The

discussions we have had since have often been tied to the many travels we have independently undertaken in and beyond the Eastern Mediterranean in the past decades. Though we took quite different paths through life to discover it, we are united by a mutual interest in the written and material traces people leave on the world. During our explorations as photographer and historian respectively, we have each come across innumerable different fragments of the past, some of which have survived in the landscapes of the Near and Middle East for centuries or even millennia. Besides the archaeological remains of Mesopotamian and other ancient urban cultures and the devastation of recent wars, these also include the traces left by Mark Sykes and François Georges-Picot's division of the Middle East in 1915. Ursula Schulz-Dornburg reminded us of this momentous event in 2018, when her exhibition *The Land in Between*, which includes photo series of the Middle East, was presented in the Städel in Frankfurt. With a few strokes of a pen on an old map, the two diplomats had marked out the border that was to separate the British and French spheres of influence from one another—a rapidly drawn line that continues to shape the political upheavals in the Middle East to this day. The casually presumptuous gesture of the two colonial gentlemen prompted Schulz-Dornburg to recall a similar endeavour, the Treaty of Tordesillas concluded in 1494, with which the kings of Spain and Portugal once divided the world between themselves. Deeply amazed, but ultimately free of illusions, we swapped stories of the hubris exhibited time and again by those who seek to control and influence the course of the world. And we spoke—our conversation meandering through contemporary history—of the arrogance with which they tried to justify or ignore the dramatic impact their actions had on their fellow humans.

Schulz-Dornburg's personal interest in this spectacular and almost proverbial division of the world in 1494 goes back to a trip she made in 2001 to Oaxaca de Juárez in Mexico, when some of her photo series were

exhibited there. During her stay, she visited the Museo de las Culturas de Oaxaca located in the former monastery of Santo Domingo de Guzmán. The museum was begun and substantially supported by the artist Francisco Toledo, who died in 2019. As a member of the Pro-OAX initiative and a descendant of the region's pre-Columbian inhabitants, he cared deeply about the cultural heritage of Oaxaca. On the one hand, he sought to preserve the memory of the native culture of the Zapotecs, to whom the majority of the inhabitants of the state of Oaxaca belonged and of which he considered himself part. On the other, he was also interested in the Spanish and Catholic influences on the old indigenous culture. Besides pre-Columbian artefacts, the museum's collection and exhibition pieces also include archival material from the era of Spanish colonial rule. With the help of this museum of cultures, those residents of Oaxaca who defined their identity through descent from Zapotec ancestors were now themselves empowered to preserve these documents, remember the Spanish conquest, and assess its consequences. Possession of the old documents granted the descendants of the indigenous peoples authority over their own history. The old documents written by the Conquistadors and their henchmen could now be exhibited as evidence of former exploitation and oppression. Presenting them in such a way was a richly symbolic act of liberation. The documents that had once manifested the Spaniards' power in writing were now in the hands of the descendants of those they had oppressed. It is characteristic of the Zapotecs that there was no attempt to shake off colonialism by ostentatiously destroying the documents as instruments of Spanish rule — as has spontaneously occurred many times in the history of the liberated, without anyone realizing in the throes of auto-da-fé frenzy that they were destroying testimonies to their own history. In Oaxaca with its Zapotec majority, by contrast, these documents were carefully preserved as evidence of how the balance of power had shifted and from then on were on presented to the public.

When Ursula Schulz-Dornburg visited in 2001, however, she was surprised to learn from the librarian that the majority of such documents are kept not in the former colonies but in the Archivo General de Indias in Seville. To give her access to this Spanish archive that same year and allow her to take pictures, the librarian gave her some paperwork that turned out to be quite mysterious: certainly, it remained incomprehensible to both the photographer and to the librarian's colleagues at the archive in Seville; but fortunately the Archivo General de Indias was nonetheless willing to give the photographer four hours in which to take pictures on the upper floor of the building, albeit without a flash or tripod.

The negatives and prints of these photographs have been stored in her private archive in Düsseldorf since 2001 and came up only when we were discussing her exhibition of 2018. My first perusal of the photos soon gave me a sense of the material and started me thinking about the Archivo General, the building and its inventory. While Schulz-Dornburg was supervising an exhibition in London and organizing another exhibition of various series at the Maison Européenne de la Photographie from December 2019 to February 2020, I delved into the history of the period around 1500, sifted through research literature and studied contemporary evidence. Deeply fascinated and inspired by the many perspectives that emerged from thinking about the archive in Seville, I wrote the text now printed in this book.

These preliminary remarks may help to clarify what inspired this text. The pictures taken in 2001, which have never been shown in any exhibition and are now to be seen here for the first time, could certainly simply be described and related to the artist's body of work. But any attempt to render in words what these images show, to translate them from one medium to another, would mean abandoning something that is unique to these images and at the heart of their mystery. And yet: by giving them some background, by explaining the reasons for their creation and the

special interest of the photographer in the history of what they show, the variety of possible meanings they give rise to in a viewer can be enlarged, conveyed and transformed, allowing them to develop their own ideas. Schulz-Dornburg's interest lay not in taking photographs of archival documents framed by impressive architecture. No. It was and still is with the *time collected* in the archive, with the stories of submission, power, control, exploitation, hope and adventure that are hidden — sometimes more so, sometimes less — in the countless documents. And with the hubris born of the exuberance of discovery, with the arrogance inherent in the historical idea that two kingdoms could simply slice the globe in half "like an orange", as a courtier of the Spanish king once put it, and divide lands both newly discovered and undiscovered between themselves.

That the photographs themselves have aged somewhat since they were taken is a stroke of good fortune for us viewing them today. Though nobody could have known it at the time, their historicity can bring Schulz-Dornburg's central concerns before our eyes even more clearly. As Siegfried Kracauer has argued, every photograph "must be essentially associated with the moment in time at which it came into existence", and therefore must be viewed with this specific temporal constraint in mind. The pictures of the archive show a present that has passed: and hence, in Kracauer's terms, "the residuum that history has discharged."[2] This special form of precipitation and the gap it creates between the viewer and what they see paradoxically bring us much closer to the time collected in the archive.

So what do Ursula Schulz-Dornburg's photographs show?

Anyone visiting the Archivo General de Indias can — having paid enthralled tribute to the impressive architecture and its manifestation of authority, to the light and how it plays in the building's space — turn their attention to the papers kept there. Their sheer volume, around ninety million documents, is almost inconceivable. If you took each sheet in hand to

study it just for a minute, you would have to spend around 520 years there, working eight hours a day. Convert that into average working weeks and you would have fifteen researchers dedicating their entire working lives to the archive, though such is the vastness of the material—if I may be allowed to extend my image—that even then they could do no more than suggest to a hundred other historical researchers a life's worth of work in a subsection of the original investigation. As their research questions grew ever more refined, thousands of others could then follow these research-ers—and still nobody would have had time to even look at the over 8,000 maps and travel notes also housed in the archive. One wonders whether the building itself would even still be standing at the end of this thought experiment—surely the paper would have rotted away in the meantime.

At all events, generations of scholars could busy themselves study-ing the information collected in the archive. To penetrate it fully is an impossible task because we read these papers not mechanically but guid-ed by our interests. Each generation would essentially have to start over, seeking and exploring from the beginning, because the questions it has for these papers would be so different from those asked by the previous one. The archive houses not just documents spanning three centuries (see Chapter I for details)—the readers of these texts also bring with them the limitations and possibilities of their own time.

Bearing all this in mind, our first glance at the boxes, in which the papers are stored, neatly labelled and numbered, may make them appear almost hermetically sealed, cold and uniform. Upon closer inspection, however, signs of use can be made out. Interested users or the archivists themselves have not always returned the papers they consulted with due care. The cardboard coverings are bent or slightly creased and let a little of their content peek through. Here and there, it seems as if someone has secretly and with childlike curiosity bent back the covers to spy out the secrets contained in the boxes. Some coverings are so damaged, one can

almost see a mysterious figure hurriedly and furtively ripping them open to get at the contents.

A closer look at the cabinets in the photographs likewise reveals where someone might have been busily searching just moments ago, hoping to discover secrets or suspecting forgotten files—perhaps they even found something. With the neighbouring cabinet, by contrast, everything seems to be waiting peacefully for someone to show an interest in the knowledge hidden here, for a researcher to ask questions only they can answer. Elsewhere, an open glass door invites us to inspect the boxes—perhaps to be disillusioned by the discovery that the script can be deciphered only by experts.

In some pictures, the collection of papers seems almost to stir, to be secretly whispering something to the viewer. These documents harbour innumerable fates and open up so many untrodden paths for exploration that the wealth of perspectives they offer can only be grasped in small steps. They record hundreds of thousands of ordinary people by name who once made their way across the Atlantic in pursuit of happiness. They can tell tales of how the local population was administered, how it was exploited, and how it suffered. They list goods that were once shipped off to find buyers in Europe, or simply to provide nourishment for the new arrivals in the so-called "New World". Sometimes we glimpse the fates of brave seafarers who ventured out onto the great ocean. The documents tell of the face of surveillance, scrutiny and distrust the royal administration showed to these adventurers—and they know about promises of happiness and the criminal energy and selfish ruthlessness that hopes to make a profit unobserved (see Chapter III).

An almost insatiable greed for gold is recorded here, as are the investments some made in order to share in this new wealth and to buttress or even improve their standing in the society of the day. Loudmouths bragged about stolen wealth, about hoards of gold and pillaged pearls.

Mythical places and idyllic realms were invented to justify or stimulate ever more daring ventures (see Chapter IV). And in doing all this, people always claimed to be acting with God's blessing. Secular conquest and the spread of Christianity were closely linked (see Chapter V) and both Christian mission and what the Church considered religious resistance, such as heresy and idolatry, are documented in the archive. The natives are presented as slave souls and animal-like beings, to whom neither morality nor Christian ethics need be applied. Although they were sometimes consulted, their foreign language documented, and more or less accurate translations of their words sought, recorded and passed on to later travellers, the aim of such endeavours was not to foster understanding, but to facilitate exploitation (see Chapter VI).

A veritable *paper empire* seems to be assembled here. The archive allows us to reconstruct the royal court with its host of officials and functionaries. Their meticulous attention to detail in administration and control emerges from its pages. The registration of all travel and the rejection of persons who were barred from crossing to the Americas for religious reasons become as palpable as the exotic goods those returning brought with them. We read of people carried off by illness at sea, hear of rebellion and mutiny, become eyewitnesses to shipwreck. The thousands of maps and travel reports show us distant countries, tell of previously unknown islands and coves that seemed so inviting and yet aroused fear of the people awaiting the sailors there (see Chapter VII). Any attempt to banish the Other with rationality or by reactivating old frameworks of interpretation collided with the fears and uncertainty associated with the remote lands and unknown regions of the earth. The extent to which such intense emotions troubled the actors and guided their action, we can as yet only begin to imagine.

The great cabinets and their well-sorted cardboard boxes shed light on these and many more facets of the past. And this is what so fascinates the

photographer: the outrageous arrogance with which people once believed that they could rule the world in league with an insatiable Church, simply split it in half and allow it to be looted without regard for its inhabitants—as long as it could be dressed up as Christianizing the world. Almost a hundred million people fell victim to this monstrous scheme (see Chapter VIII).

Given this historical background, the architecture and the meticulous order of archival bookkeeping—with the once distinctive aesthetic reflected in the photographs—seem like a luminously seductive but ultimately hollow mask: a contrast that fuels the exceptional and quite peculiar tension lingering at the heart of this place.

But there remains one important thing to add, about the historical uniqueness of the photographs themselves, which imbues them with a special aura. The form of archival presentation they depict is now itself a thing of the past. A few years after the photos were taken, the Archivo General de Indias was completely renovated, reopening in 2004. For conservation purposes, the files are now kept on the ground floor of the archive in climate-controlled rooms with heavy steel cupboards. In this warehouse of knowledge, the marble floors and old ornate shelves made of Cuban cedar and mahogany have been replaced by modern archival furniture, which serves only to preserve the documents and not to display them framed by magnificent state architecture. Researchers wanting to study individual files can now order the relevant bundles in a catalogue and reading room at Casa Cilla, a historic building located south of the archive on the other side of Calle Santo Tomás but connected to it by an underground tunnel dug shortly after 2000.

The mahogany shelves on the first floor, where Ursula Schulz-Dornburg photographed in 2001, are now either populated with empty cardboard dummies or clad with black cloth, ready to be converted into showcases for temporary exhibitions. Dressed up in this way with the

techniques of modern museum presentation, the old inventory was most recently on display in the exhibition *El viaje más largo. La primera vuelta al mundo* (2019/2020), a celebration of the 500th anniversary of Magellan's circumnavigation of the world.[3]

If you stroll through the first floor of the archive today, you will see only empty copies of the original old archive boxes photographed in 2001. Today's visitors see only a simulation of what the photographs still depict, a reality that has now itself become historical. What remains is the mise-en-scène of an architecture of power stripped of the documentary proof to back this power up. To the archive's director and his staff, this is of course not a drawback, but an expression of archival progress and the obligation to treat the papers with care and, if necessary, to extend their life through restoration. Royal ostentation has been replaced with state-of-the-art, climate-controlled filing cabinets and a new, digitally equipped reading room. An intricate and expensive tunnel system that is invisible to the visitor connects the old and the new. Needless to say, these changes too are a product of their time. At the same time as the closed, scholarly archive was redesigned, the rest of the building was opened up to tourists—a historically significant concession to contemporary city and exhibition tourism.

In the following pages, however, we shall travel back in time to 2001 and beyond, taking the chance to build on the original symbolic function of the Archivo General de Indias. In this volume, pictures and text meet to exchange stories, both those they themselves have experienced and those far in the past, about things they have seen with their own eyes and about remote events handed down in old texts. For a picture to speak clearly, the light and the shades of grey have to be just right, and the reproduction of what the negative has frozen in time must be almost perfect to the eye of the artist, even in print. It is only fitting, and of course in the historian's interest, that the accompanying historical narrative be reliably researched and well told. The gaze one directs through the lens of a camera is—how

could it be otherwise—informed by personal interests, biographical vicissitudes and artistic ambitions. The same applies to the historian gathering information and old testimonies and reading carefully selected books.

As the viewer alternates between the text of the historian and the razor-sharp and at the same time mysterious black-and-white photographs, a motley jumble and juxtaposition of stories, eras, events, actions and fates emerges. Peering into this historical kaleidoscope promises new insights and the occasional moment of incredulous amazement. Perhaps it will provoke questions that draw attention to new perspectives and encourage us to read further. Perhaps then we may hope that the photographer and the historian will no longer be alone in exchanging ideas and reflecting on *their* truth with its many shared details, but that readers will develop an interest in participating in this conversation—and perhaps develop their own, completely different truths from the photographs and text presented here.

We are now taking the first step on a journey that will take us back five hundred years—to a time when men were planning how to find a western sea route to India without any real sense of the dramatic consequences such voyages would have—and into a magnificent building, filled with documents that tell of this time.

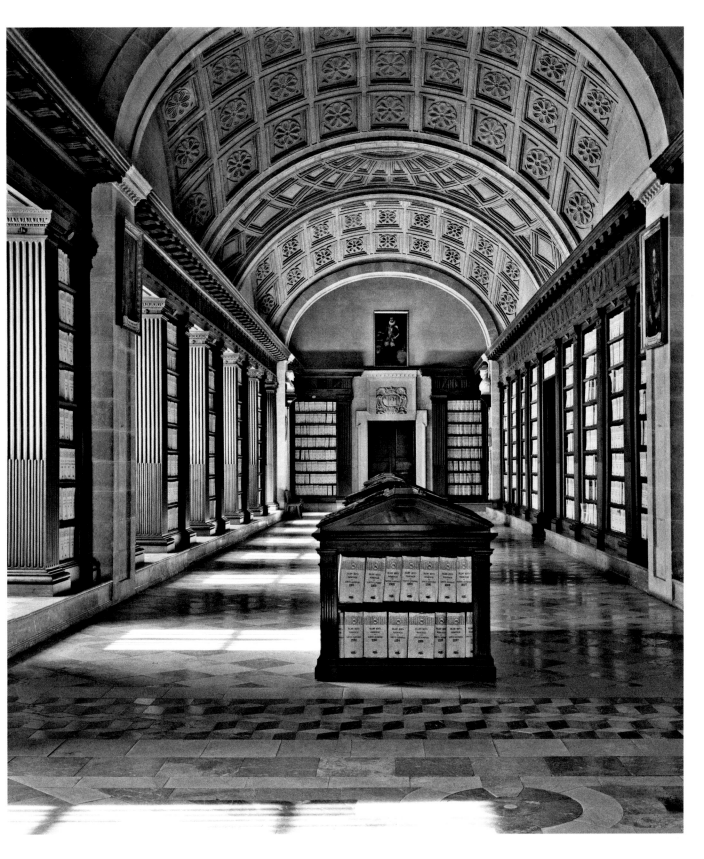

I. An Archive as a Monument to Power and Historical Retrospection

The word "archive" comes from the Latin *archivum*, meaning a cupboard or a large number of files used to store documents of various kinds. The files are generally no longer being used in day-to-day business but are considered worth preserving for various reasons. The term applies not only to the files themselves but also to the building holding them. Anyone who has ever visited an archive knows that they are usually located in basements and cellars. To the layperson, they seem to be storing confusingly vast amounts of paper. In establishing an archive, the focus is not on the beauty of its architecture or the pleasing presentation of the files stored there, but on its functionality and usability. Neither those commissioning these buildings nor their archivists and visitors are interested in the impressive effect of the rooms and the way in which the files are collected in boxes, folders, cardboard sleeves or similar containers. The overall design, archiving process and long-term care are guided by the need for reliable storage and ease of retrieving individual documents in the future.

And yet, as historian Achille Mbembe has pointed out, the status and power of any archive are inconceivable without its architecture.[4] The physical space, the furnishings used, the labyrinthine corridors, the sheer order of the documents and their grave and careful handling in semi-darkness all imbue even a common archive with an atmosphere

reminiscent of a temple or cemetery. This sacred aura is reflected in the rituals of archiving and the strict regulations surrounding the archive's use. Archives remind us of burial sites, Mbembe argues, since the authors of the documents have all died and the lives of the dead rise up from the texts themselves.

We recognize this haunting effect of the premises and the documents they contain in Ursula Schulz-Dornburg's photographs of the Archivo General de Indias in Seville.[5] And yet the breath-taking architecture of the Renaissance building and the lovingly planned interior make it stand out from the innumerable, drab collection points for records scattered across the world that Mbembe obviously has in mind.

The architectural design is so grandiose because the building in Seville originally functioned as an exchange (the Casa Lonja de Mercaderes), and was therefore planned as a suitable architectural setting for Spain's overseas trade.[6] In the 16th century, the long-distance merchants who had met on the steps of Seville's cathedral to do business for many decades wanted somewhere they could gather regardless of the weather. Between 1584 and 1598, the Spanish king, Philip II, had the Casa Lonja built to serve as an adequate setting for their flourishing business, a setting that blended in perfectly with the Royal Palace, the Alcázar, and the imposing Cathedral of Seville, the Giralda. (UNESCO declared this ensemble of buildings a World Heritage Site in 1987.)

Two hundred years later, under Charles III, it was decided to establish in this building the central archive for documents of the Spanish colonial period, every one of them unique and of inestimable historical and cultural value. The choice of building may well have been an easy one, because Cádiz had increasingly replaced Seville as the main trading port since the 17th century and the merchants had mostly moved on. The immediate historical background to the establishment of the archive was the order the king had given the historian Juan Bautista

Muñoz in 1779—at the instigation of the important courtier, minister and nobleman José de Gálvez y Gallardo—to write a new *Historia del Nuevo Mundo*.[7] The aim of this multi-volume project was to counter recent portrayals of American colonial history that had appeared in England and France, among other places, and were spreading what the Spaniards considered a "black legend" about their unjustified claims to ownership and the violence they had perpetrated.[8] Muñoz began collecting material in Spain's various archives and came to the conclusion that a central collection of all documents would make this and other tasks considerably easier. Gálvez had already had the same thought and, in close coordination with Muñoz, began to urge the scattered archives of Spain to send relevant documents to Seville. Together, the two men set out to catalogue and archive the incoming materials.

The holdings they collected in Seville in 1785 were no longer meant to serve the day-to-day administration but instead, in line with Gálvez and Muñoz's thinking, were to be consulted primarily as material that allowed a view of the past guided by the interests of the Spanish crown. The colonial era was now understood as a field to be tilled by the nascent profession of historian. In the Age of Enlightenment, scholars had gradually become aware that such archival holdings should be understood as sources to be explored for historical insight. That only material stored in the old archives from before 1760 was to be moved to Seville gives another strong indication of the logic behind this almost unimaginable mass of papers. All more recently archived materials, as well as those yet to come, were to remain in their customary locations. In this way, historical documents were separated from those still currently in use by government and administration: almost as if the archive itself divided time, separating a grand past from a slightly less grand present.

The choice of building and its location at the heart of power made immediately clear that the files the scholars collected here and put on

display behind the glass doors of the cabinets were to be imbued with pre-eminent significance. The archive's symbolism and charisma undoubtedly played a decisive role. In their report from 1784, the two architects entrusted with setting up the archive emphasized that the building was without parallel in Spain in terms of its elegance, solidity and balanced architectural proportions. The king shared their view: he wanted to ennoble the materials stored there. More than that, his choice of building reflected the value these materials had, not only for Spanish scholars of the time but also for the Spanish crown itself for more than 200 years. Muñoz himself also considered proximity to the court highly important since it allowed easy access, facilitating communication and coordination between scholars and the royal house.

Henceforth, the documents gathered on the upper floor on nine kilometres of shelving—the ground floor still housed a consulate (Consulado Marítimo y Terrestre de Sevilla)—would stand as a symbol of the former and by then gradually fading majesty of Spain. The history of Spain's time as a colonial superpower, already nearing its end in the late 18th century, began with the discovery of America in 1492 and the famous Treaty of Tordesillas that followed, by which Portugal and Spain divided the world between themselves in 1494 (see Chapter VI for details). The four papal bulls of Alexander VI that had already set out this division of the world in various stages in May of 1493 and the treaty itself were, despite the changed political situation at the end of the 18th century, particularly prominent among the documents of the archive in Seville—as they still are today.[9] You could almost say that these documents were the seeds from which the rest of the files grew. The Spanish Empire of the 16th century, the empire that Tordesillas facilitated, was a global empire unlike any that had previously existed in world history. At that time, its European territories included Spain, the western Mediterranean islands (including Sicily), the Netherlands, Luxembourg,

Burgundy and parts of northern Italy, as well as, outside Europe, parts of North Africa, large parts of the Atlantic Ocean and its islands, large swathes of North, Central and South America and even islands in the Pacific Ocean.

By the time the archive was set up, everyone knew that the Spanish Empire had long been in decline.[10] The process had begun in the 17th century, when the Iberian Peninsula was plagued with troubles. On top of famine, social unrest and other crises, new competitors, like the Netherlands, England and France, began to acquire overseas possessions, especially in North America. The new colonial powers supported piracy, providing ships and military backup to such glittering characters as the Welsh pirate and later governor of Jamaica Henry Morgan. This severely affected Spanish trade in Central America. The Spanish king continued to control the Iberian heartland and some overseas colonies, but his military might in Europe was seeping away. On 13 January 1750, Ferdinand VI of Spain and King John V of Portugal finally signed the Treaty of Madrid, in which these once so important colonial powers redistributed their zones of influence in the overseas colonies. This did not so much abolish the division of the world Spain and Portugal had set out in Tordesillas in 1494 as make it more accurate, above all with regard to the western border of Brazil. The treaty was adjusted to the factual state of ownership, which meant in favour of Portugal. However, even this new treaty was unable to stop the ongoing enfeeblement of the Spanish Empire, which was shedding individual territories throughout the 18th century and lost more and more of its imperial possessions from the beginning of the 19th century onwards.

Twenty-five years after the Treaty of Madrid, the new archive was intended to reify the impressive grandeur of the story of Spanish colonial rule, which had begun in 1492/94 and by 1785 was almost 300 years old. In retrospect, this act of imperial self-historicization looks almost like a

prophylactic effort to survive its own decline—historiographically, at any rate. While the king and his advisors did care about preserving the documents for their individual value, they cared also about the sheer volume of material assembled and how this would reflect on the kingdom. The monarch was well aware of both the historical and the metaphorical significance of such a huge archive.

For millennia—since the first written records were created—paper and writing have given material form to power. Rule first manifests itself in the physical presence of the rulers, which their subjects experience in the form of military control and the development of sophisticated administration. This presence has always included the written documentation of their actions. Already in the Mesopotamian city-states of the 3rd millennium BCE, in the great empires of the Middle East, in Pharaonic Egypt and the Mycenaean palaces of the late 2nd millennium BCE, appropriate forms of recording information on clay tablets or on papyrus were being invented and progressively refined. Turning administrative decisions into texts and archiving the relevant documents was not just the motor of how institutions pervaded these empires; the state's ability to issue tax demands, or even simply to name which of its subjects had already fulfilled the obligations imposed upon them and which had yet to do so, was also a very concrete symbol of the authority of the state in a written document. It made sense to preserve such documents as stores of knowledge, to collect them and to systematize their archiving. Being able to make inquiries in the archive about a ruler's subjects at any time made large-scale monitoring and control possible.

The ways these ancient empires organized themselves in their first attempts to perfectly penetrate their dominions—ways that in retrospect look like early iterations of the centralized planning and surveillance of everyday life—resurfaced in the administrative control practices of the 16th-century Spanish monarchy, even though they were imple-

mented without any specific knowledge of their ancient forerunners.[11] For the bulk of the documents at least, the prehistory of the archive at Seville began when Christopher Columbus "discovered" America for Europe in 1492.[12] In the same year, but quite independently, the scholar Elio Antonio de Nebrija published the first grammar of Spanish (*Gramática de la lengua castellana*), followed by a Spanish–Latin dictionary in 1494. For Nebrija, the Spanish language, now in use also in the colonies, was the "companion of empire".[13] With the expansion of Spanish rule into the "New World", archives were set up that were of surprising size by the European standards of the time. The same can be said of Portugal, where the archives in the Torre do Tombo of the Royal Palace in Lisbon had been created already in 1378 and subsequently served to document Portuguese colonial rule. The archiving technology used there also set the standard for the Spaniards, with Spanish archivists incorporating elements into their own plans after visits to Lisbon. In any case, the Portuguese example clearly showed that running an empire with overseas territories required centrally concentrated archives of trade, seafaring and taxation.

King Ferdinand II began collecting documents on the voyages of discovery in 1492 and from 1509 onwards these were stored in the old Chancillería of Valladolid. Among the Spanish archives, the Archivo General de Simancas, established by Charles V in 1540, ultimately became the most important. The castle of Simancas had already proven its use as a central prison and royal treasury. In 1574, Philip II expanded the heavily fortified archive in the castle into a comprehensive store of knowledge about the newly conquered regions. In 1588 the monarch drafted a first set of rules, setting out the objectives and duties of the royal archive in great detail—at the time, an unprecedented document in the history of archives. It shows how important the crown archives were to the Spanish regime, far more than a mere collection point for

documents. They were at the same time a symbolic place of memory for the Habsburg dynasty and a haven for their cultural and especially Catholic identity in a period of religious wars. A restrictive access policy and specialist archive personnel, who managed the files and regulated and monitored access to the documents, ensured that the archive quickly became—like the archives of the judicial authorities and chancillerías in Valladolid and Granada—a secretive institution, which held detailed documentation of royal possessions and various kinds of financial claims. As a consequence, the files were secured in multiple ways and could only be accessed with permission and in the presence of the archivists. It has been said that over time this facility built up a veritable "paper empire" and ultimately served as the "paper foundation of order".[14] This view may be somewhat one-sided, as it ignores other mechanisms of power, such as the inspections of office-holders and written and oral interrogations among others, and overestimates the functional importance of archives by making them the central mechanism of control and knowledge.[15] It does, however, correctly reflect the effort with which documents were collected and preserved.

Along with royal documents and the records of the various ministries, Simancas also housed the files of the Casa de la Contratación (Casa y Audiencia de Indias), which had been founded in 1503 in Seville, the most important port for long-distance trade at the time, on the initiative of the Archbishop of Burgos. This royal institution exerted sweeping control over the expeditions of discovery and conquest. As a kind of chamber of commerce, it oversaw the Castilian monopoly on trade in the colonies—entirely in accordance with the principles of government by written record described above. The Casa de la Contratación raised taxes (the so-called "royal fifth"), documented all shipping traffic, granted licences to captains, provided the necessary shipping documents and inspected ships, though from 1523 it operated under the adminis-

trative control and jurisdiction of the Royal and Supreme Council of the Indies (Consejo Real y Supremo de Indias). Thanks to the extensive powers and meticulous bookkeeping of the Casa de la Contratación, we now know by name more than 150,000 people who travelled to the New World at the time.[16] The Casa also controlled all matters relating to emigration and systematically excluded criminals, vagabonds, Jews, Muslims, forced converts and those with Muslim or Jewish ancestry, all in order to ensure that new territories were solely in the hands of Catholic Spaniards. In addition, this agency gathered all old and newly acquired knowledge about travel routes and the associated nautical details.

All information received about the colonies and their geography converged here. A large part of the inventory of around 8,000 maps and plans now held in the Seville archive can be traced back to the work of the Casa and the Council of the Indies. The archiving of records of trade and the various taxes and dues was of immense importance to the kings. These revenues were the material basis for their policies in Europe and especially for warfare in the Old World. As a bank, the Casa was also tasked with using the wealth pouring in from overseas, which came from mining precious metals, selling enslaved people and exporting goods to Castile, to repay the debts incurred by the regular military campaigns in Europe.

All documents collected in Simancas and other archives with similar contents were transferred to the Archivo General de Indias in Seville under the direction of Juan Bautista Muñoz in 1785. No one at the time could have had any idea of the downfall and ultimate disappearance of the Spanish colonial empire. But contemporaries were certainly aware that, in comparison to the 16th century, Spain's significance in the geopolitical struggle of the major European powers had shrunk.

These documents, visible from 1785 onwards through the glass windows of locked cabinets that were (and are) opened only to those with

a legitimate interest, maintained the function they had already had in the earlier archives: to act as an instrument of power. The sole master of the various archives, now merged for the first time, was of course the king, who was therefore also the master of this mass of knowledge that stood for political control.[17] The state's historical memory was at his discretion, because he determined what was preserved and what was— in the language of the archivist—"withdrawn", and thus destroyed, made invisible.

While the kings of the 16th and 17th centuries had insisted on secrecy and an asymmetry of knowledge, the move to the old exchange building meant that this policy was at least partially, albeit minimally, relaxed. In return it was expected that people would marvel at the former size of the empire. The king's intentions in establishing the archive and the historical interests of Gálvez and Muñoz were both directed towards comprehensive control over how these documents were to be interpreted. By archiving certain documents and granting permission to consult them, the master of the archive and his prominent accomplices seized an opportunity to take control of the past. Neutralizing accumulated guilt was a central concern of archivists and visitors alike in the early years of the archive, always in competition with the histories then being written in other nations.

Access to the files was strictly regulated. The new archive's lack of a reading room already makes clear that long visits were not a consideration when the interior was planned. Nobody was to be inspired to use this material to write an unauthorized history of Spain that did not toe the royal line. The statutes published in 1790 stipulated that no one was allowed to make copies of the documents, and even hinting at their existence or content was prohibited. We may note in passing that, despite his exclusive rights of access, Muñoz himself never finished his *History of the New World*, apart from the first volume, which ended with the year 1500.[18]

The Archivo General de Indias monumentalized the colonial period of Spain. Inaugurated by Columbus's first journey in 1492, it was a historical epoch that was almost outrageously transformative—and not only for Spain. The news of the "New World" fundamentally changed all then held notions of the Earth. Those involved understood the encounter with hitherto unknown cultures across the Atlantic as a dramatic turning point in how they experienced the world—and described it accordingly in the printed reports of their travels.[19] Or, as the philosopher Louis Le Roy put it around 1570: "[…] the invention of the printing press and the discovery of the new world; two things which I always thought could be compared, not only to Antiquity, but to Immortality." According to Francisco López de Gómara in his *Historia General de las Indias* from 1552, the discovery of America was—"excluding the incarnation and death of Him who created it"—"the greatest event" in the history of the world. And even at the end of the 18th century, Adam Smith could still pointedly state in *The Wealth of Nations* that "the discovery of America, and that of a passage to the East Indies by the Cape of Good Hope, are the two greatest and most important events recorded in the history of mankind".[20] By then, hundreds of tons of gold and thousands of tons of silver had already been transported to Europe—quite apart from all the other goods and a great number of enslaved people. Many more enslaved African people and European migrants, as well as goods of all kinds, had likewise embarked on the journey west, making their way, on an even larger scale, to what was then considered a truly "new world".

It was the Florentine merchant Amerigo Vespucci who first spoke of the "New World" in 1503, after having crossed the Atlantic himself. His travelogue, printed in the form of two letters in many European cities, was accordingly entitled *Mundus Novus*. Prompted by his friend Matthias Ringmann, the cartographer Martin Waldseemüller named the new land in honour of Vespucci on his 1507 world map, though he naturally gave

the name its female form: America.[21] According to Ringmann, who wrote the commentary on the map with Waldseemüller (*Cosmographiae Introductio*), Amerigo Vespucci was to be regarded as the true discoverer of the new continent, especially since scholars were still all speaking of India or, with Columbus, of the West Indies: "But now these parts have been extensively explored and a fourth part (of the earth) has been discovered by Americus Vesputius, as will be heard hereafter: I do not see what right any one would have to object to calling this part after Americus, who discovered it and who is of shrewd wits, hence 'Amerige', that is Land of Americus, or 'America', since both Europe and Asia were assigned their names from women".[22] With this proposal, Ringmann and Waldseemüller provoked a more than 300-year-long dispute over who had discovered America. Vespucci or Columbus? Florence or Spain? Was the new continent really to bear Vespucci's name, that of a thief, a "pickle-dealer at Seville [the Florentine's place of residence], whose highest naval rank was boatswain's mate in an expedition that never sailed",[23] as Ralph Waldo Emerson grumbled at the beginning of the 19th century? Was not the Admiral Columbus the real discoverer, as the Spanish monk Bartolomé de Las Casas had already emphasized: "No one can presume to usurp the credit, nor to give it to himself or to another, without wrong, injustice, and injury committed against the Admiral, and consequently without offence against God."[24] Vespucci's fellow citizens in Florence naturally saw things quite differently. As late as 1788, they emphasized that: "The universe [...] regarded him as the confidant of the stars, as the father of cosmography, as the wonder of navigation, and, having by the unanimous suffrages of all nations abolished that primitive denomination the *New World*, willed that the continent should derive its name from Americus alone [...]."[25] Vespucci himself, however, laid no claim to the privilege of first discovery. As Alexander von Humboldt finally determined, it had not been Vespucci, but Waldseemüller and his colleague Ringmann who

were the first to reproduce both the Old *and* the New World on a single map in 1507 and had thus established the new name.[26]

Perhaps the best way to visualize this dispute and the upheaval it caused at the time is to imagine the surprising discovery of a new world beyond the Atlantic as the discovery of a new, inhabited planet—the reports of those returning from overseas seem to have been received with a quite comparable mixture of shock and fascination. Everything people heard, read and saw seemed almost incomprehensible in its novelty and strangeness.

Just as fascinating were the white spots on the Earth that the discovery of new countries and islands paradoxically created. The news of previously unknown lands sparked the imagination and made people dream of the many other discoveries that suddenly seemed possible. There appears to have been a near inexhaustible supply of such newly opened or merely imagined perspectives on the world—and the hopes attached to them. Although people knew that the Earth was round, there were, beyond what the ancient geographers had posited, no concrete ideas of exactly what it was like and what secrets it held. The uncertainty left ample scope for new plans and imagined scenarios. This applies of course to all the greedy adventurers, rulers and poor souls who dared to make a new start away from home. But it applies to the scholars of the time as well. The Englishman Thomas More and his famous short book *Utopia*, published in 1516, make a good example. *Utopia* is the fictitious travelogue of a sailor supposed to have crossed the Atlantic with Amerigo Vespucci, but who then went further still and discovered an island called *Utopia*, where he found the perfect republic. This not-(yet)-existing place has since become a powerful symbol for all wishful thinking and all visions for the future that are unlikely to become reality—but it also reminds us that dreaming up utopias allows us to shed all the fetters placed on us by our particular experiences.[27]

To us, with our radically different experiences of space, the notions of the Earth held around 1500 make sense only with some effort. In order to understand the ideas of that time and the context that made it conceivable to contractually divide the world into two hemispheres and two dominions at Tordesillas in 1494, we are forced to take a few detours. Our concrete experience of the world as a whole, as a complex global entity, is a relatively new phenomenon whose origins the following chapter will trace out. Next, we will need to reconsider divisions of the world, like the one implemented by Spain and Portugal, as an anthropological constant in human history. People have always divided up the world—separating their immediate environment and experience from the spaces inhabited by other people. History allows us to study many examples of such divisions and their lengthy consequences. Knowledge of these long past examples was very much available around 1500 and formed the foundation on which a comparable agreement in the Age of Discovery was thinkable at all and could be imagined as a sensible course of action. The division of the world in 1494 has a specific place in a contemporary culture of knowledge. Without the invention of the printing press, which greatly promoted the distribution of classical texts as well as the travelogues of the discoverers, other narratives would have been written. With its fruitful combination of old texts and new horizons of experience, evident in the books of the time, we may even understand this radical transformation as a media event as well.[28] Finally, we will see that the kings' sheer lust for power, despite their treaty of division, gradually and paradoxically paved the way to seeing the world as a coherent whole both in the mind and in cartography, and to depicting it in new stories and new maps. Their greed for occupation and plunder and their division of the world into halves, were decisive in leading people to speak of the Earth as an undivided whole.

But first, we travel back a mere 50 years into the past, to a time when the spatial experience of people around the world changed drastically.

The act of leaving the Earth for the first time and the early journeys into space were great sensations of their time — and for those who witnessed them, those events remain vividly present still.

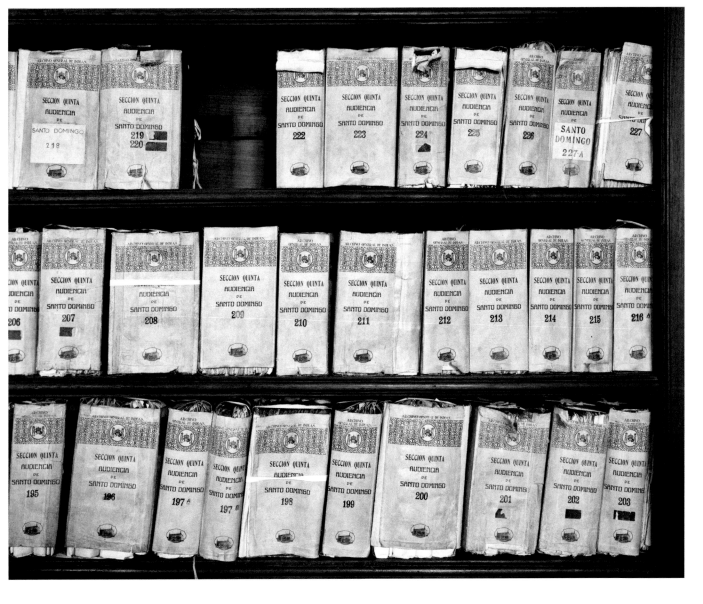

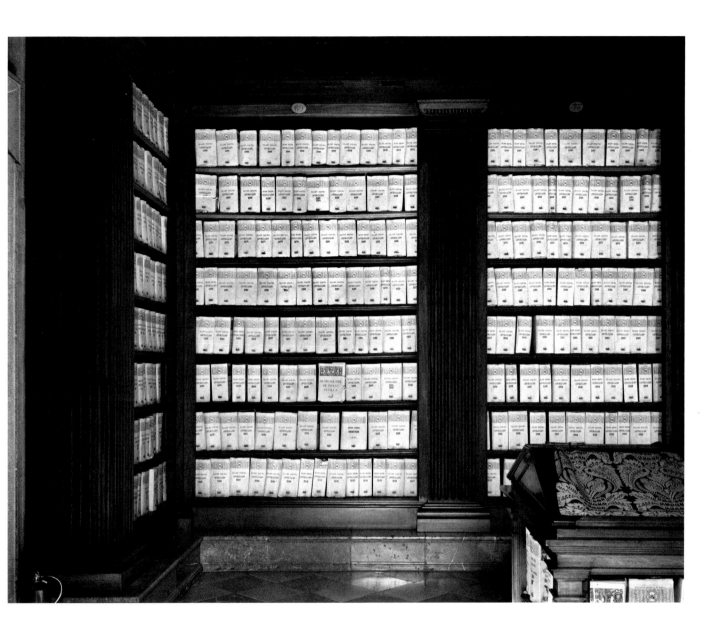

II. The "Overview Effect"

The US space agency NASA keeps a photograph, filed under the number AS814-2383HR, that has made history. The picture was taken on 24 December 1968 at 16:38 (Universal Time) from the cockpit of the Apollo 8 mission. During this manned mission to the moon, the astronaut William Anders, equipped with a Hasselblad camera and a 250mm lens, was tasked with photographing the moon's craters through the small window of the spacecraft in order to identify a safe landing site for the projected moon landing. At that moment, as the capsule re-emerged from behind the moon, the Earth suddenly rose into view in the window. Commander Frank Borman looked out in surprise and the microphones onboard recorded Anders' remark: "Oh, my God! Look at that picture over there! Here's the Earth coming up! Wow, is that pretty!" Anders immediately took a picture of the rising Earth with his Hasselblad camera, with Borman jokingly commenting: "Hey, don't take that, it's not scheduled." Since the film in the camera was black and white, Anders shouted to his colleague Jim Lovell to quickly toss him a colour film. Film recordings from the cockpit, available on the NASA homepage, show Lovell hastily searching for a film, which Anders quickly put in the camera. Borman asked him to take several colour pictures with the Kodak Ektachrome 70mm film; all three astronauts were completely enthralled by the impression of that blue planet against the grey lunar wasteland in the foreground and the blackness of space in the background.

The astronauts sent a picture of the rising Earth to Houston that same day. Since it was Christmas Eve, they combined the picture with a Christian greeting to the world. The world, meanwhile, was spellbound in front of the TV, eagerly absorbing all the latest news of the mission. Borman recited the first line of the Old Testament creation account in his greeting and wished everyone a blessed Christmas. But it was the photo of the Earth itself that left the strongest impression and which was to have an enormous impact under the title "Earthrise" in the years that followed. The outside view of the planet had already made a deep impression on those manning previous space flights, but the astronauts of the Apollo 8 mission were the first to see the globe as a whole and the first to be able to capture it on film. What really was so stunning about this photograph?

The time of the Apollo programme was shaped by the dream that humans might be able to leave the Earth and explore new worlds. These fantasies had much in common with the hopes that have driven all expeditions, explorers and adventurers in history. The dream of space evoked a vision of leaving behind all the imperfections of our earthly existence, the political conflicts, wars and environmental disasters, and, just as all those colonists and explorers of distant countries had done throughout human history, braving a new beginning — on an island utopia, you might say, only translated into space.[29]

After leaving the Earth's atmosphere behind, however, the astronauts flying into space on the Apollo missions saw not a colourful new world but an infinitely black and threatening void. The nearby moon did nothing to mitigate this experience, because — as William Anders said many years later — that grey satellite seemed peculiarly barren against its pitch-black background, offering nothing to the eye except "all shades of grey".[30] Earth, that blue planet with its glowing bands of cloud, looked like a distant but familiar oasis in this black expanse of nothingness

with the lunar landscape in the foreground. At the same time, the Earth evoked an overpowering sense of longing for home, security, family and friends.

But the planet did more than bring back personal memories and make you yearn to return to your familiar and simpler life. Since Yuri Gagarin first circled the Earth on 12 April 1961, cosmonauts and astronauts have repeatedly spoken of how their experiences transformed their view of the Earth. The view from orbit awakened in every one of them a new way of seeing their planet, to which Frank White finally gave a name in his 1987 book, *The Overview Effect*.[31] In written records and interviews, space travellers unanimously emphasized that flying into space had fundamentally changed their ideas about the Earth. They had an impression of the planet as the common home of all humankind, which they for the first time recognized as a complex and coherent organism. At the same time, it seemed extremely fragile and endangered because—as the astronaut Ron Garan put it in 2008—the atmosphere separates the earth from death and the horror of space as if by a narrow, paper-thin film.[32]

The space travellers brought back to Earth their vision of the fragile yet breath-taking unity of the planet, to which political borders and man-made divisions and enmities meant nothing, and retold it in interviews and books. But it was the "Earthrise" image itself that had the strongest impact, together with a much-reproduced photograph known as "Blue Marble", a view of the whole Earth without any darkening shadows taken by the crew of Apollo 17 a few years later, on 7 December 1972. Both photos became icons of the environmental movement then emerging around the world, which held the inaugural *Earth Day* in the United States in 1970. The organizers printed the "Earthrise" photo onto countless posters and banners to be hoisted during rallies and demonstrations. The US Postal Service had already in 1969 chosen it as a motif for a stamp, accompanied by the words *In the beginning God…*, the opening of the biblical account of

creation quoted by Borman. The research carried out by ecologists, who had been describing the Earth as a complex ecosystem since the 1950s, now received an omnipresent visual confirmation.

With the new missions of the 1970s, above all the Soviet and American space stations, space was increasingly understood as a place where the world, divided by the Cold War and military conflicts, could be united in a scientific, outside perspective. When the USA and the USSR agreed on 17 July 1975 to plan and undertake joint missions in the future, this too was a result of the space travellers' "overview effect", which culminated in 1998 in the International Space Station (ISS), now operated with support from 16 nations. Admittedly, the collapse of the Soviet Union and the relaxation of relations between East and West were important prerequisites for this cooperation. And the US's insistence that China be categorically excluded from the station to this day makes it clear enough that, despite the overview effect, political confrontations on Earth continue in space. As is to be expected, the perception of the Earth as a cohesive whole, unprecedented in human history in this form and propagated by the crew of Apollo 8, has had little impact on *realpolitik*. Regardless of the astronauts' experience that all man-made boundaries become insignificant when viewed from space, politics remains dominated by an us vs. them mentality and by divisions of the world into good and bad.

For a number of years now, the Overview Institute, founded by former astronauts and other space enthusiasts, has been striving—with almost touching naiveté—to stop the experience of the overview effect as a "metaphysical, philosophical and aesthetic epiphany" from being marginalized. The aim of the project is to make as many people as possible aware that the overview effect is a "fundamental perspective-altering experience".[33] Commercial space travel for everyone and the application of new media are meant to offer this experience to as many people as possible, so that the concomitant effect is not restricted to the approximately 500 space

explorers to date. The founders see this as an important contribution to addressing our current problems of climate change and shortages of food, water and energy as shared issues that affect us all.

But in view of the technological developments that have shaped the past decades, this initiative must appear downright romantic. The development of long-distance travel, the speed of transportation and, last but not least, the networks of information spawned by computers and the internet have introduced new ways of seeing the Earth into the discussion.[34] The invisible exchange of information in particular has given rise to the idea that the globe is no longer an adequate representation of our earthly realm. In the age of so-called globalization, the image of the globe no longer seems able to properly depict the new forms of communication and the tangle of global interdependencies. New forms of maps are called for: the phenomena of globalization cannot be fitted into the old frames.[35]

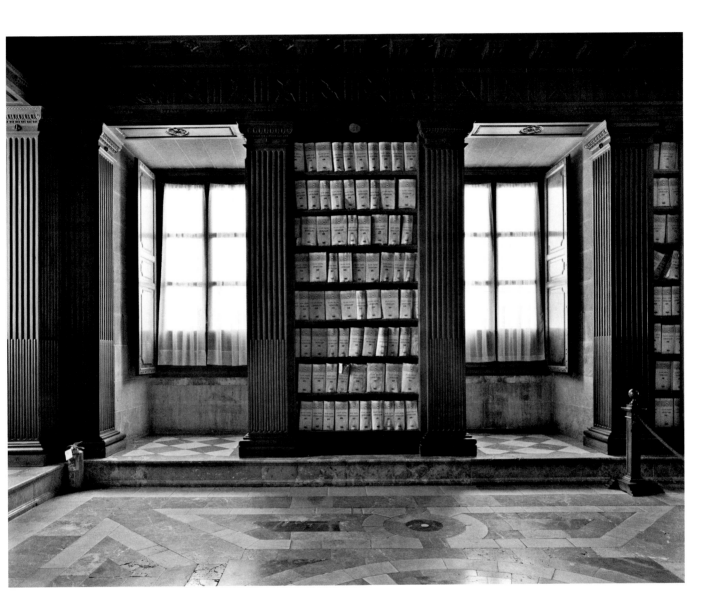

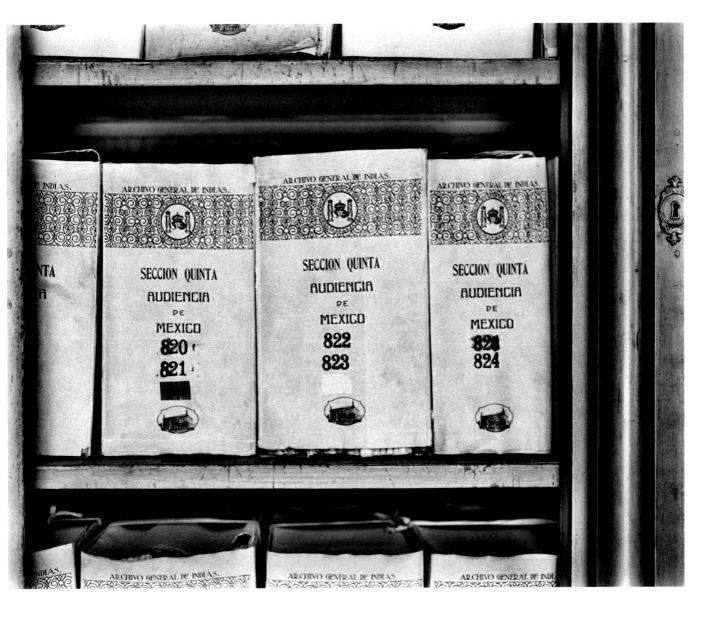

III. Divisions of the World

Astronauts describe their feelings at seeing the Earth through the small windows of their spacecraft so emphatically because, of course, they know that the perspective back on Earth was and is so utterly different. Every rocket launch, every orbit around the globe and every journey to the moon reinforced the perception of the Earth as a fragile but unified celestial body, but also contrasted with the everyday experience of the astronauts in a world that was fragmented in so many ways. Indeed, you could say, with some justification, that the division of the world has been a constant in human history. From that history's earliest stages, we can see the spaces of one group's experience being distinguished from those of more or less distant others.

We can trace this clearly enough from the beginning of the ancient written record. The scholars of 1500, to whom we are now slowly returning via a detour into the ancient imagination, knew this very well. In early written records, the geographical order of the world is already determined by people defining a specific place as (their) centre of the world. Around this central point, which was the space of their own everyday life, narrowly understood, they imagined the rest of the world rippling outwards in concentric circles towards an unknown and uncanny edge. At the same time, they consciously decreed that the centre, where they lived, was the home of all good and familiar things. They had made themselves more or less comfortable in their own world and internalized the social hierarchy

in which each person had their assigned place. They understood that their own lives were properly ordered according to a framework that was lawful, or at least reliably communicated by their rulers. The distant edges, by contrast, signified the uncanny, the Other, or even the part of the world that was inhabited by terrifying monsters.

At this abstract level, these fringe zones were also conceived of as spaces in which one might pass into the sphere of the gods. A space that could be physically visited and experienced was thus superimposed onto a symbolic or mythic one. On the Babylonian world map from the 7th or 6th century BCE, the oldest known visualization of such ideas on a clay tablet, Babylon and the surrounding regions of Mesopotamia naturally serve as the geographical centre.[36] Around it, organized in a star shape beyond the border of the world—the bitter river *marratu*—we find mythical landscapes inhabited by divine beings. Dividing the world into different spheres played a vital role in the mythological tales of this far-away space. In Mesopotamia, as in many other regions of the world, these areas are commonly assigned and entrusted to different gods. Among the Greeks, for example, Zeus ruled over the inhabited world, Poseidon over the seas and Hades in the underworld—in myth, this was a fair division between three divine brothers. Far to the west of this world divided among gods lay Elysium, the Isle of the Blessed—an idea that proved extremely attractive to the explorers of the early modern period, especially since Elysium had been considered an earthly paradise since the late Middle Ages.

From the very beginning, the earliest attempts to organize the world geographically combine empirical and mythical space.[37] The two partly overlap, especially since they were brought together literarily in the particular space of epic. The edges and boundaries of the world do, however, mark a line of separation, beyond which eerie and dangerous regions could be imagined, up to and including the world of the dead. Being mythical places, these areas beyond the borders cannot be mapped with

any sort of precision, for example in a seafarers' handbook, but can only be conveyed, for maximum impression and effect, by *storytelling*. The more impressive the story, the greater its impact on the imagination. In antiquity, such places were localized in many different places over time. Paradise and the afterlife, for instance, were sometimes thought to be located on the moon.

This cultural division of the world into a centre that can be experienced and an unknown world beyond its borders is absolutely fundamental to how ancient cultures imagined themselves in geographical terms. Throughout antiquity, this way of dividing the world was never abandoned, despite new discoveries and despite the progress of the sciences, which increasingly conceived of the space of the Earth and the cosmos in geographical, mathematical or astronomical terms. Even when the centre of the world was no longer located in Babylon, but first in the sanctuary of Apollo at Delphi, then in Rome and finally in Christian Jerusalem, these shifts were not necessarily based on a kind of scientific consensus; they merely reflected how the centres of real political and religious power changed over time.[38]

When sailors, undeterred by the power of such stories, began, from the 5th century BCE onwards, to venture into the Atlantic (thought to be an impassable sea full of deadly dangers) or explored the west coast of Africa, something remarkable happened after their return. When writing their travelogues, these explorers, such as the Carthaginian Hanno who explored West Africa, by no means corrected the old mythical tales or exposed them as mere fancies.[39] On the contrary, they told of monsters and the terrible dangers they had withstood, and in some cases even embellished the mythical tales. The same applies to the Romans. When they conquered Britain, for example, and extended their empire to the North Sea, they continued to write the old stories about the borders of the world. Here were viscous, unnavigable seas full of sea monsters. Even a Roman

senator and consul like the historian Tacitus considered such uncanny tales of the unnatural world of the North Sea plausible when he wrote in the 2nd century CE—and, like many of his contemporaries, he too thought that those living on the coast in the far west could hear a faint hiss when the sun sank into the sea.

There was ultimately no alternative to this ethnocentric vision of a world divided into self and Other. People could maintain the superiority of their living space and culture only by continuing to portray the foreign and newly explored regions as another world devoid of cultural order, full of horrors and dangers. Such worlds were inhabited not only by monsters but even, it was alleged, by humanoid beings with the most peculiar anatomy. People told tales of beings in India that consisted only of a head and legs or had ears so large that they could curl up in them at night. Such fantasies continued to have an effect until modern times. Foreign peoples like the Indians apparently adapted themselves to whatever they learned of the world view of the Greeks.[40] When Alexander the Great reached the Ganges river with his soldiers, one of his generals, called Nearchos, reported that Indian envoys had supplied the soldiers with the skins of fox-sized ants that, according to Greek and Roman tales, dug for gold in Asia. The native Indians probably gave the newcomers skins from marmots, which—as modern observations in the region have shown—have gold-coloured fur.[41] To claim that these were ants confirmed the mythical ideas of the Greeks—surely a profitable gesture. Such peculiar gifts, which reflected the imagination of the conquerors but contradicted the experience of the givers, obviously benefitted the diplomatic interests of the latter. In this way, the mythical space was transformed, in collaboration with the strangers, into a reality with apparent empirical support.

The ancient Persians provide another example of such a division of the world into a positively defined centre and an inferior or dangerous fringe. The great king Darius I (549–486 BCE) described himself as "king

of kings, king of the countries with all tribes, king on this great earth far and near". The god Ahura Mazda had granted him this rule and he had "struck back the enemy far from Persia".[42] The 5th century BCE Greek historian Herodotus provided his compatriots with an explanation of the Persian king's conception of centre and periphery: the Persians, Herodotus declared, "honour most of all those who dwell nearest them, next those who are next farthest removed, and so going ever onwards they assign honour by this rule; those who dwell farthest off they hold least honourable of all; for they deem themselves to be in all regards by far the best of all men, the rest to have but a proportionate claim to merit, till those who dwell farthest away have least merit of all."[43]

In these ideas we recognize again the concentric division of the world, in which poorly known strangers and their idiosyncrasies are denigrated or even outright despised. Darius I's sovereignty over the centre of his empire, granted by the god Ahura Mazda, legitimized the domination of these "inferior" people in the eyes of the Persian king — or at least, that is how the Greeks saw it, who understood that they themselves were living beyond the borders of the Persian Empire, namely, west of the region of Lydia in Asia Minor. Darius himself had an altogether larger space in mind: "This is the realm that I have in my possession, from the Saka that are beyond Sogdia to Nubia, from India to Lydia." This imagined Persian space concentrated on the great Persian Empire and only hinted that something other existed, which however it left unnamed.

The Greeks themselves also elaborated upon the widespread notion of a world divided and busied themselves drawing new boundaries. Alongside their fundamental divisions of the world into heaven and earth, this world and the next, the known and the unknown, their voyages of exploration and trade contacts required them to divide the world into a space they themselves inhabited and the places where others dwelled. These latter spaces were considered part of the inhabited and known world,

called the *oikumene* since the 5th century BCE. Over time, the distinction between this and the outside space beyond the borders of the world, which was either desert or inhabited by mythical creatures, was further refined. They began by distinguishing between Europe, Asia and Libya (North Africa) — thus separating the different continents. Far more consequential than such a geographical scheme of organization, however, was the Greek conception of the Other and how they perceived, defined and segregated others. Such processes became more dramatic and explicit the more entrenched the community either was, seemed to be, or — and this is a particularly powerful stimulus for such narratives — was not, while wishing to *appear* like a unified and solid community both to itself and to others.

We can see this mechanism very clearly in the aftermath of the Persian Wars. The final victory of the Greeks over the Persians in 480/479 BCE resulted in a division of the world that in essence went on to be imagined in different variants and flavours for more than 2,000 years and in part persists to this day.

This is evident, for example, in the debate sparked by the book *Orientalism* by Edward Saïd, published in 1978.[44] In it, the author criticizes the West for its feeling of superiority over the "oriental" societies of the East and especially over Islam. This finds specific expression in a form of intellectual disregard, which at the same time results in attempts at domination and control and contrasts the enlightened, reason-directed West with an inferior, mystical Orient.

The invention of the Orient that Saïd investigated and the separation that comes with it have their real roots in 5th and 4th century BCE Greece. An increased awareness of the identity shared by the Greek city-states was not the only legacy of the Greeks' triumph over the superior strength of the Persian armies. Some Greeks, such as the orator Isocrates, began to paint a crude, exaggerated picture of the Persians, designed to

58

present them as the polar opposite of the Greek community. Unlike the free, self-determined citizens of, for example, the radical democracy of Athens, the Persians were presented as slaves of a soft, emasculated king devoid of any self-control, who indulged in chaotic violence and sexual excess alike.

The vehemence with which the barbaric East was set up as an Other, especially in Athens, was based purely on a calculating lust for power. As is still common today, internal dissent was to be quieted by building up an external enemy. The constant assertion that the Persian barbarians were still a danger and sought only to enslave the free Greeks was the ideological foundation for the rule of Athens in the Delian League. In the decades after the Persian Wars, this league brought together around 200 city-states in an alliance to protect against the danger allegedly posed by the Persians—and soon provided the basis of Athens' rule over large parts of Greece, the Aegean and the coasts of Asia Minor. Athens exercised a form of rule within the league that the Athenian historian Thucydides openly called a tyranny, given its overt use of extortion and military intervention. We have long known that despite the propagated division of the world into the European Greeks on the one hand and the Asian Persians and their neighbours on the other, there were many productive and friendly contacts between these two "halves". Members of the Greek elite, diplomats, traders, artists and, not least, mercenaries, vigorously cultivated relationships across the divide.

The division of the world promoted by the Greek side, however, acted as a blueprint that has often been adopted and adapted as a model in Western history. Hence why we must constantly remind ourselves of this tradition, a tradition still vigorously alive in the modern era. We can trace how effective an image the "despotic Persian king" has been by looking at its millennia-long history. The Romans at first took over this dichotomy to set themselves apart from the Parthians and then, from the late 2nd

century CE onwards, from the Sassanians. In the European literature of the Middle Ages and into modern times, this image, which had been modified and reiterated until Late Antiquity, was given new life in multiple ways. Likewise, the division of the world of the past into civilized Greeks and inferior barbarians, West and East, Occident and Orient, Europe and Asia remained an essential point of reference for the drawing of ever more boundaries, seized on by the various rulers of the Mediterranean world, with the Romans leading the way. Even in the contemporary accounts of the various peoples on the move during the so-called Migration Period in Late Antiquity, these old patterns are recycled with tiresome monotony, sometimes even as direct quotations from the old traditions.[45]

The images and blueprints developed in ancient literature remained active because these texts were copied over and over again and then distributed and read in print from the 15th century onwards. They were still highly influential in the Age of Discovery of the 15th and 16th centuries.[46] The protagonists of this period invariably drew on books by ancient authors and not just to compensate for a lack of geographical knowledge. Rather, the ancient books provided metaphors and modes of description that could also be applied to the new countries and peoples first discovered around 1500. Seafarers and explorers drew on their knowledge of ancient literature to try to convince financiers that the purpose of their expedition was sanctioned by ancient testimony. And they spread reports of miraculous encounters and peoples which they copied from old accounts, in the hope of captivating the reader or listener with the adventures they had supposedly experienced. The Greek author Megasthenes, for example, whose writings are lost today but are cited in many ancient texts and were once well known, had already demonstrated around 300 BCE how stories of distant islands brimming with gold could stimulate the public's imagination and desires. In the 14th century, an unknown author who called himself Jean de Mandeville, followed Megasthenes' example and sold his

contemporaries skilful compilations of ancient accounts of one-footed, dog-headed, and flower-eating peoples as new travel narratives.

In the Age of Discovery, these ancient stories of wonders were imbued with new value. The tales of Marco Polo's travels had already offered ample material on the wonders of distant lands. Evidently, the best way to convey the wonder and astonishment of the novelties you had seen was to describe these prodigies in the manner of the ancient authors. Columbus, too, adhered to the ancient tradition in describing such miraculous observations in his ship's logs. On 9 January 1493, he recorded in the logbook that he had seen sirens (*serenas*), or in other words mermaids, near Haiti, observing that in reality they looked different from what is commonly imagined in Europe: "They were not as pretty as they are depicted, for somehow in the face they look like men." On 4 November 1492, he wrote that he had asked the locals about miracles, whereupon they reported that "far from there, there were one-eyed men, and others with snouts of dogs, who ate men, and that as soon as one was taken they cut his throat and drank his blood and cut off the genitals".[47] On his second trip, he sent enslaved people, whom he believed to be cannibals, back to the royal court. They were to be isolated and taught Spanish in order to make them lose their old identity and abandon their cruel rites.

Miraculous reports about the locals thus went hand in hand with their enslavement, which was justified by pointing to the strangeness and inferiority of these peoples. An example may serve to show how influential such ideas were, affecting even the royal chancellery. When the Spanish royal couple opened the "New World" for private voyages of discovery in 1500, their main interest was to share in the profits of these private entrepreneurs, in imitation of the Portuguese model. In a royal letter granting Captain Rodrigo de Bastidas from Seville the right to sail with two ships "at your own expense and risk across said Oceanic Sea", the chancellery gives a detailed account of the goods subject to royal taxes and tariffs.

The document states that the royal couple laid claim to 25 per cent of the net profit after "deduction of expenses for equipment, freight and other costs", so to their share "of all gold and silver, copper and lead [...] as well as of all pearls, precious stones and jewels, of all slaves, blacks and dark-skinned people"—and "of all monsters and snakes".[48]

The ancient geographer Strabo and the Roman polymath Pliny, who propagated the stories about such monsters that they found in their sources, such as the writings of Megasthenes, offered attractive narrative models. Like many other ancient authors since the time of Herodotus, both of them repeatedly emphasized that they considered such miraculous figures pure fiction. Nevertheless, they reproduced the old descriptions, knowing full well that this was exactly what their readers expected to find in their books. The same applies to many Renaissance authors. When at the end of the 16th century Jean de Léry tried to sort through his impressions of Brazil in his travelogue *Histoire d'un voyage fait en la terre du Brésil, autrement dite Amérique*, first printed in 1578, he relied on his knowledge of ancient authors to guide his quill. Everything in America is so different from Europe, Asia and Africa, "that it may very well be called a 'New World' with respect to us". He had to admit that he was now seeing the ancient authors in a completely new light: "I am not ashamed to confess [that] I have revised the opinion that I formerly had of Pliny and others when they describe foreign lands, because I have seen things as fantastic and prodigious as any of those—once thought incredible—that they mention."[49] The origins and intellectual history of the marvellous fantasies and imagined monsters of the Middle Ages can be easily traced today,[50] as can how they found their way onto early modern maps.[51] Only in the 17th century do these creatures gradually begin to disappear from newly drawn maps and nautical charts.

At the same time, however, the Dutchman Theodor de Bry and his sons rekindled contemporary ideas about the horrors of the New

World—or at least shrewdly responded to the wishes and expectations of their buyers, as the great success of his prints shows. Between 1590 and 1634, he printed 25 folios under the titles *America* and *India Orientalis*, all of which collected travel reports from the New World.[52] However, the volumes owed their immense impact not to their reproduction and translation of old reports but to their illustration of the stories in 600 coloured copper engravings. They featured depictions of all the horrors of the New World—often purely imaginary—and were to shape notions of the "savages" inhabiting the newly discovered countries for 200 years. Their truly horrifying scenarios of extreme violence portrayed those living overseas as the very antithesis of civilized Christians. 200 years after Europeans first laid eyes on America, such books still sold extremely well. Although by the end of the 16th century far more was known, they continued to repeat the tales told by the early seafarers. As historian John H. Elliott discovered to his surprise while looking through contemporary chronicles, including Charles V's autobiography, it seemed that "at some point the Europeans had, so to speak, closed the shutters, as if they had, suddenly overwhelmed by the many things that were to be seen, recorded and understood, crawled back into the gloom of their old intellectual world".[53]

From a different point of view, this demonstrable incomprehension of the "flora and fauna or [...] the peculiarities of its inhabitants" can also be seen as an instrument of power. Miracle stories were an element used to formulate and legitimize claims to power. As literary scholar Stephen Greenblatt has put it: "The marvelous is a central feature then in the whole complex system of representation, verbal and visual, philosophical and aesthetic, intellectual and emotional, through which people in the late Middle Ages and the Renaissance apprehended, and thence possessed or discarded the unfamiliar, the alien, the terrible, the desirable, and the hateful."[54]

Besides the letter quoted above, written by the royal couple for Captain Rodrigo de Bastidas in 1500, the archive of Seville contains numerous documents that take the marvels of the flora and fauna of the New World as their theme. There are also various missives that speak of local eyewitnesses claiming to have seen wondrous things. Given the great wealth of new animal and plant life in the newly discovered countries, it is not surprising this continued for generations.

At the same time, the 16th century also saw deeper interest and reflection, as is evident from the so-called *Codex Florentinus*, a truly unique specimen among the contemporary reports from the New World. This codex, held in the Biblioteca Medicea Laurenziana in Florence, contains the last extensive copy of the *Historia General de las Cosas de la Nueva España* (General History of New Spain), compiled by Bernardino de Sahagún, between 1540 and 1585. In this work, Sahagún describes the Aztec Empire on the basis of his intensive research among the locals, which included interviews conducted in various indigenous languages. The *Historia* was written in Spanish and Nahuatl, the language of the native Aztecs and neighbouring tribes of Mexico. This is very significant since the Spanish Inquisition, led by Bishops Fray Juan de Zumárraga and Diego de Landa, had destroyed all texts written in indigenous languages by the Maya and other cultures. Sahagún's text dealt with the social structure, the world of the gods, and more. It also highlighted the dramatic consequences for the Aztecs of the excessive violence and looting and the diseases brought in by the conquistadors. The text Sahagún recorded in Nahuatl deserves special attention and not only for its value to historical linguistics. The Aztec translators of these sections repeatedly used them to brazenly criticize the colonists. Given Sahagún's diversity of interests, his use of local languages and the more than 1,800 images illustrating the work, the *Historia* can fairly be considered an early form of ethnography.

It is hardly surprising then that the Council of the Indies in Seville not only prevented its publication but attempted to confiscate all related manuscripts written in local languages—for fear that they might spark the subjects' self-confidence and cause them to turn on the conquerors. That many documents kept in the archive of Seville itself were swarming with terms drawn from local languages did not, however, concern the authorities. There, the use of such language was simply designed to make it easier to manage and collect taxes.

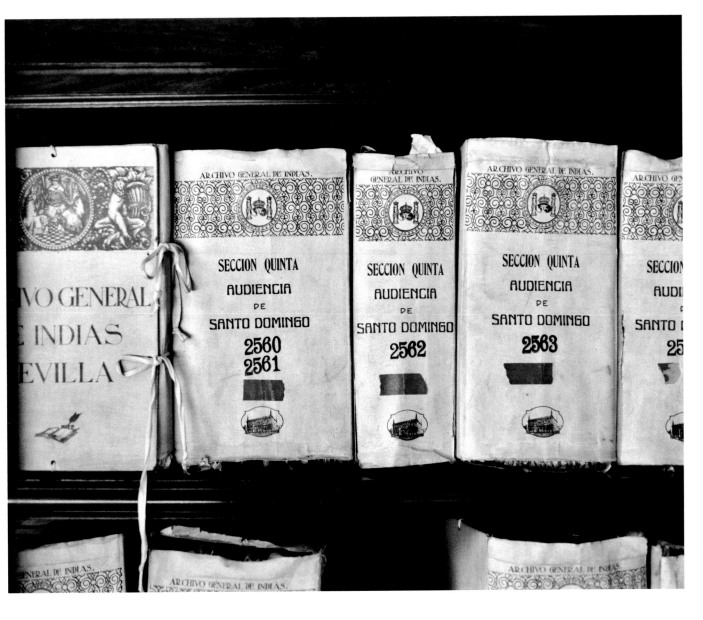

IV. The Divided World of the Mediterranean and the Myth of Gold Over the Seas

Exceptions like Sahagún's book notwithstanding, which had little impact since they were produced only in small numbers and soon banned, narratives remained a central medium for describing the wonderful and the strange. For most people at the time, however, the discovery of the New World and the sea route to India were made real by the previously unknown goods of all kinds now being brought in through European ports. The archive in Seville contains countless lists of imported goods and the taxes due on them. Precious metals, foodstuffs, spices, exotic plants and animals as well as enslaved humans from Africa and from across the Atlantic all astounded the people of the day.

Thanks to the conquests and discoveries of the Portuguese and Spaniards, the 16th century was quite literally a golden age, founded on plunder and legends of unheard-of treasures. Spain especially has been associated ever since with a veritable "hunger for gold", which seemed almost insatiable.[55] It had clear parallels with the Ancient Romans' "hunger for silver", which was much lamented by the Greeks and which Rome ironically at first tried to satisfy by ransacking Spain.[56] Bernardino de Sahagún let Aztecs themselves describe the Spanish greed for gold: "They [the Spaniards] are mighty thirsty for gold, their body elongates, they become wild with hunger for it. They were greedy for gold like hungry pigs".[57]

This greed had often been aroused by mere stories, patched together from exaggerations and brazen lies. The travelling seafarers had been promised wealth, the existence of which had not or could not be verified. By contrast, the conquistadors' actual plundering of South and Central America was often driven—though this in no way excuses their behaviour—by the financial pressures weighing upon them. They had taken out large loans to fund their expeditions, which had to be repaid. The crews received a share of the plundered goods as pay—a custom reminiscent of the predatory practices of the Ancient Roman legions. The nobles who set out on such voyages needed their loot to establish their social standing among their peers and open up opportunities for investment.

A typical and famous representative of this group was Hernán Cortés, who raised an army to invade the Aztec Empire in 1518. As a rebel acting on his own initiative, he needed to be economically successful at any cost. With only a few hundred soldiers he managed to capture the Aztec ruler Moctezuma in the middle of an empire with millions of inhabitants and had himself taken to the gold mines. This was the beginning of the end of the Aztec Empire, which paid a terrible price over the following two decades: violence, but above all epidemics, claimed some 15 million of its inhabitants. A hundred years later, 97 per cent of the 25 million people that had inhabited the region at the beginning of the 16th century had been wiped out.

The treasures Cortés shipped to Spain, in particular the treasure of Moctezuma, certainly fired the imagination of his contemporaries. In 1520, the painter Albrecht Dürer, having marvelled at the precious objects, wrote in his diary: "I also saw the things that were brought to the king from the new golden land: an entirely golden sun [...] and all sorts of wonderful things for human use, that are much nicer to look at there than wondrous things [...]. And I haven't seen anything in my whole life that my heart was so pleased with as these things."[58]

More and more new myths about the riches of America began to circulate. Thousands of adventurers set out in a gold rush for Mexico and South America. The emerging legend of El Dorado, the mythical city of gold in the heart of the South American continent, lured countless travellers across the Atlantic and continued to do so for centuries. It took Alexander von Humboldt to dispel this powerful legend as fantasy, though by then thousands of locals had already fallen victim to violent gold hunters. Another set of such tales told of the "Seven Cities of Cibola" in Mexico and likewise lured conquerors all the way to the Pacific Ocean. Locals gladly took advantage of such legends, pointing the conquerors to ever more remote regions in order to get rid of them elegantly.

The political and military threats people faced at home in the Mediterranean in the early 16th century made the search for such wealth all the more compelling. They hoped for a Golden Age in the New World (or saw one coming) not only because of the riches being unloaded in the ports almost every day and the new prospects opening up overseas, but also because their own Mediterranean world had been forcibly divided for centuries.

To the kings and the popes, the military successes of the explorers in the New World put the Eastern powers they saw as such a grave threat to the Christian, Catholic West in their place. The Mediterranean world of the 16th century was in large part an Islamic world: the East and all of North Africa were in Muslim hands. After the fall of Constantinople in the second half of the 15th century, the Ottoman Empire extended already into the Balkans. Given the religious hostility between the two sides, this division of the Mediterranean world was reminiscent less of the collapse of the Roman Empire into a Western and Eastern Empire than of the Ancient Greek contrast between European civilization and Asian barbarity. The Greek tradition of constructing a divided world was thus updated with great insistence.

One example of the narrative patterns used may suffice to illustrate the point. Already in the 15th century, Enea Silvio Piccolomini (1405–1464), who headed the Curia as Pope Pius II from 1458, was drawing clear demarcating lines in the style of the ancient division of the world into Europe and Asia. Shocked by the fall of Constantinople in 1453, the Pope called in his writings for the Turks to be excluded from a common tradition of ancient foundational legend, in which Troy played the main role. Like all European powers and empires, the Turks had been integrated into this tradition since the 7th century. In fact, the scholars around Mehmet II, the conqueror of Constantinople, even presented the victory over the hated Orthodox Greek Church as an act of revenge for the fall of Troy. The Pope now vehemently countered such attempts to incorporate the Muslim conquerors into the old, Trojan founding myths of the European powers. Pius II tried to prove, by referring to ancient authorities, that the Turks descended from the Scythians, the "dirtiest and basest tribe, whorish in all types of fornication". Far from being part of a common tradition, the Turks were said to be intent on destroying the Western *studia humanitatis*.[59]

The expansion of Islam, which was perceived as a huge threat to Christians, weighed heavily on European countries and the Roman Curia. In response, they attempted to neutralize and overcome the division of the Mediterranean world and the Islamic control of the East less by seeking major military conflicts in the Balkans or Asia Minor, than by opening up a new world altogether. The New World was meant to compensate for what had been lost—or better yet, surpass it. The sea route to India around the southern tip of Africa, for example, allowed Western merchants to sail around the old silk route under the Arabs' control.

With Cortés, the conquest of the Aztec Empire and fantasies of fabulous golden treasures, the history of expansion had clearly reached a climax. By this time, Europe's resistance to Islam also had a long history.

In the course of the *Reconquista* in the 13th century, the Portuguese had already been able to defeat the Moors (Berber tribes Islamized by the Arabs) on the Iberian Peninsula and to extend Portugal's borders to the Strait of Gibraltar. In 1415, the Portuguese began to gain a foothold on the North African continent. Fortresses were erected and trading houses established. Under the leadership of Prince Dom Henrique (also known as "Henry the Navigator") they explored the Atlantic and the west coast of Africa and the Muslim trade monopoly, mainly in enslaved people and gold, was gradually broken up. In 1486, the Portuguese finally reached the southern tip of Africa and named the promontory *Boa Esperança* (Cape of Good Hope), hoping that they might finally reach India from there. They worked feverishly to make their navigation more precise, improve their geographical knowledge and build up their fleet. With the caravel, they had already developed a type of ship superbly well suited to long-distance travel.

In 1482, a sailor from Genoa, Christopher Columbus, suggested to the Portuguese king that he sail west and seek out another way to India. Since his plan fell on deaf ears, in 1492, he turned to the Spanish royal couple Ferdinand II and Isabella, who provided him with ships and thus made the discovery of America possible. The Portuguese and Spanish alike now made a host of new discoveries in rapid succession. There were successful expeditions to new countries almost every year, with the Portuguese concentrating on the east coast of Africa (Madagascar, Mozambique), the Indian Ocean (Malacca, Colombo, China) and South America. The discovery of Brazil (1500) and the first news of the lands later called Newfoundland, Labrador and Nova Scotia made clear that there was a huge continent south and north of the countries and islands discovered by Columbus.

Contemporaries eagerly followed the seafarers' reports of foreign peoples and admired the new fauna and flora revealed to them in pictures and through imported goods. Portugal now dominated the trade in

spices and other riches of the East, which had formerly been in the hands of the Muslims. The division of the Mediterranean world into the Christian West and the Islamic East had thus been partially overcome, at least as far as economic profit was concerned.[60] People noted with satisfaction that Granada had been wrested from the Muslims in 1492, the same year as Columbus's expedition, and would henceforth be under Christian rule. The compulsory baptisms the General Inquisitor and Cardinal Francisco Jiménez de Cisneros ordered in 1499 among the last Muslims in Granada and elsewhere—the so-called Mudejars, whose Muslim beliefs had initially been tolerated under Christian sovereignty—were met with widespread applause. Despite the claim that all Muslims in Spain had been defeated and forcibly baptized, tales of Muslim pirates who continued to terrorize the seas and compel Christians to convert proved tenacious and were still popular in the 18th century.[61]

In Castile at least, the American conquests began just as the Muslims seemed to have been subjugated. This success reinforced the fantasy that ever more new, as yet unknown riches were to be gained overseas. At the same time, contemporaries were always vividly aware of the dangers the seafarers were taking, especially since accidents and deaths were often reported. These too are documented in the Seville archive. Antonio de Guevara (c. 1480–1545), an important scholar at the court of Charles V and who was widely read in the early 16th century, summed up his experiences after a number of voyages: "A person who goes to sea and does not do so to lighten his conscience, to defend his honour or to earn his livelihood is either a fool, suicidal or should be imprisoned, since he must surely be insane".[62] There were, of course, more than enough men who "had to earn their livelihood" in the ports of Portugal and Spain, so that new adventurers and fortune-seekers were always setting sail. The many horror stories in circulation, however dramatic they may have sounded, had little impact on the numbers. When Álvar Núñez Cabeza de Vaca

published his *Naufragios o La relacion y comentarios del governador Alvar nuñez cabeça de vaca, de lo acaescido en las dos jornadas que hizo a las Indias* in 1542 about his disastrous expedition of 1527 and the shipwrecks he himself experienced, his account could certainly be read as a debunking of the myths of discovery, but it did not change much in practice.[63] For many decades, people continued to tell of the marvels and inexhaustible riches of the New World.

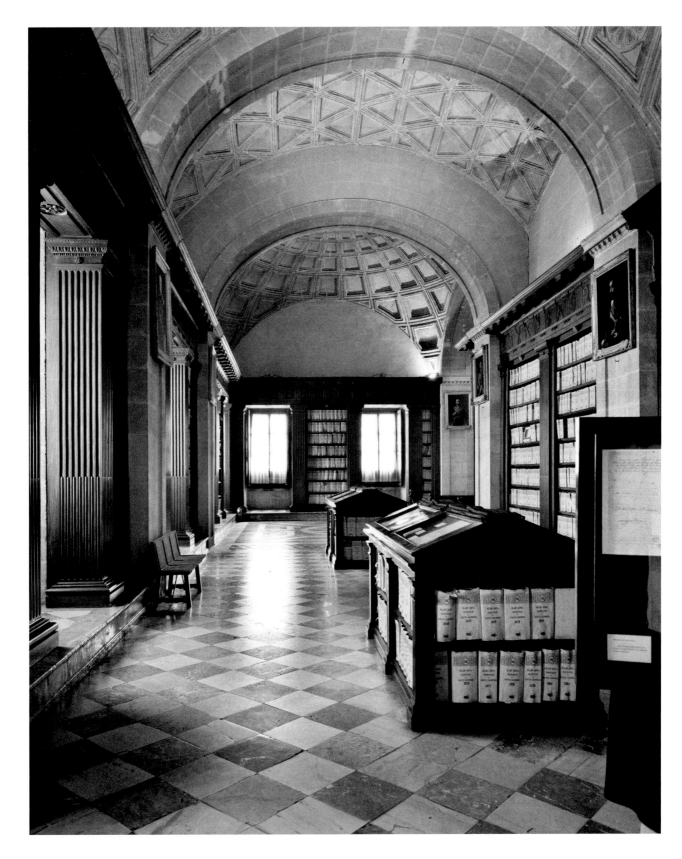

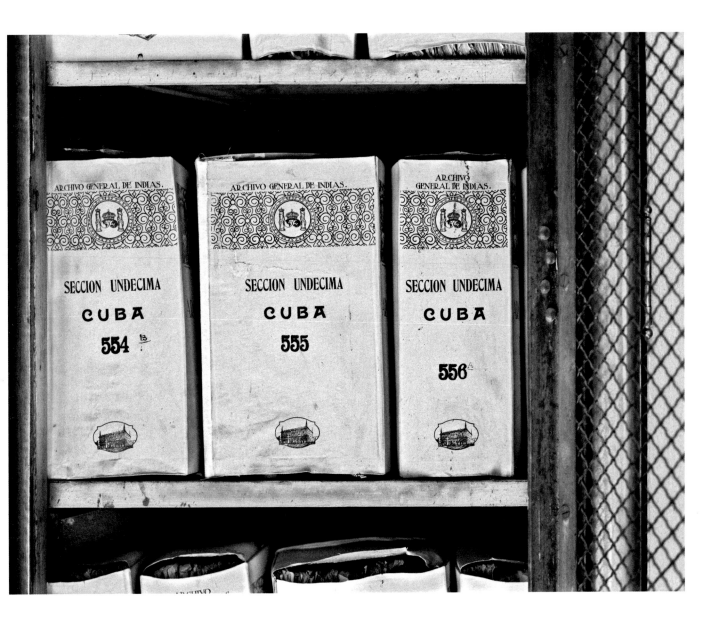

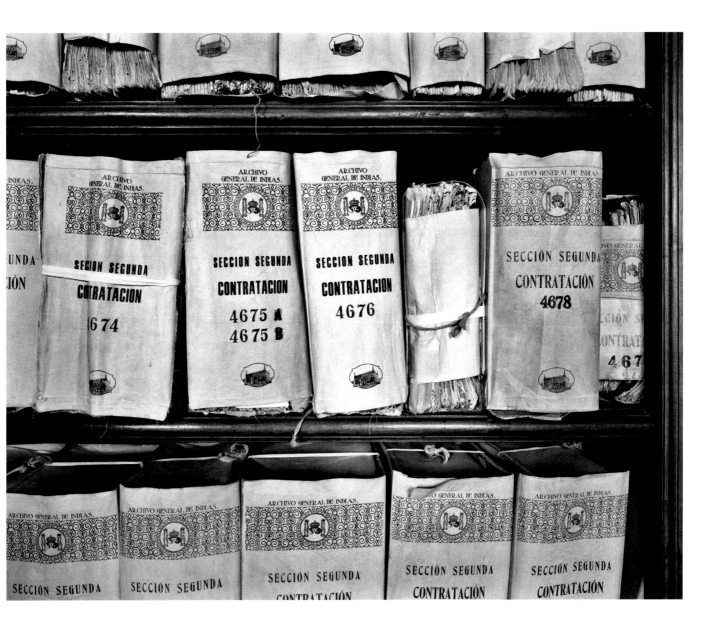

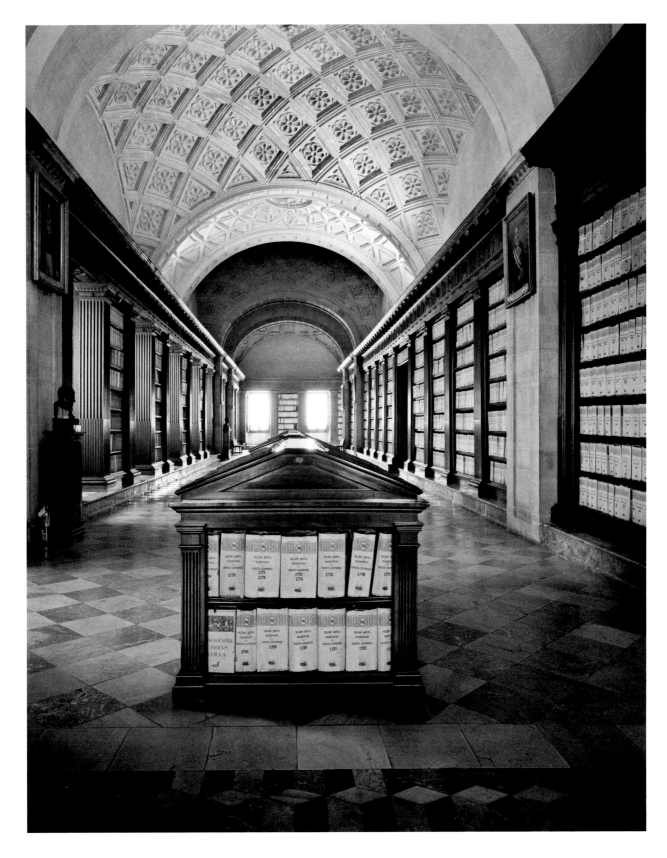

V. Celebrating the New World — Expansion and the Exchange of Gifts

The popes in Rome observed the new discoveries with great interest. With an eye on Muslim expansion, they were keen to ensure that the old hegemony of the Church would extend to this New World as well. While the Church thus certainly had idealistic, or rather religious, interests, a certain desire to gain financial compensation for the territories lost also played a part. The Church's world supremacy was supposed to have been established back in the 4th century by the so-called Donation of Constantine. Although this document had long since been exposed as a forgery, for example by Lorenzo Valla in 1440,[64] this mattered little to the Catholic Church. Despite such clear philological evidence, the Curia still sought to claim and secure its supremacy over the new lands.

To achieve this aim, the Church undertook a variety of diplomatic activities from the 15th century onwards. The exceptionally good sources for the important Renaissance Pope Leo X allow us to see the kind of initiatives typical of the time. A member of the prominent Medici family of Florence, Leo ascended the Apostolic See in 1513. In his communications with the new colonial powers, particularly with Portugal, he was able to continue the established rituals of his predecessors. But for around ten years, one particular contact played a special role for Leo X, namely the Portuguese king, Manuel I. Many documents attesting to their intense exchange still survive today.[65]

Early in his kingship, nearly two decades before the beginning of Leo X's pontificate, Manuel had commissioned Vasco da Gama's expedition to find the sea route to India. In the years after, Portugal increased its sway along this sea route and in India itself. The popes in Rome supported this policy with numerous bulls and breves, confirming Portugal's ownership of these new areas. Leo X was able to build on these measures, with significant help from Manuel I. The Portuguese king made it easier for Leo to grant him what he wished by employing an old diplomatic ritual in a thoroughly adroit and unprecedented manner. It was customary for kings to recognize new popes by paying homage through envoys, who would generally both give and receive precious gifts. Since ancient times, such exchanges of gifts among rulers have aimed to establish symbolic agreement, assure mutual respect and underwrite future joint action. To an early-modern ruler, such embassies also provided an opportunity to display their wealth and ask for support from the Curia. Back in 1505, two years after Leo X's predecessor, Julius II, had become Pope, Manuel I had selected magnificent gifts to show his appreciation. In addition to a silver cross, he had sent many exotic animals for the Vatican menageries. In return, he received a gold rose weighing several kilos as well as a consecrated epee and a general's hat, both traditional, valuable signs of papal recognition for political and military achievements.

Leo X naturally kept a close eye on the Portuguese conquests himself. In January 1514 he wrote to Manuel I that, thanks to the successful conquests, he expected to see all of Africa christened soon and the faith spread to other regions around the Indian Ocean. For his part, Manuel I hoped that these missives from Rome meant the Pope would also support the planned conquests financially, since financing for the expeditionary fleets remained precarious, despite all the new wealth. Spain and Portugal were also engaged in a properly diplomatic competition over the Curia's recognition of new conquests, particularly in Asia. The bone of

contention was the Spice Islands, or Moluccas, which played a key role in the long-distance spice trade.

To lend extra weight to his demands, Manuel I concentrated on putting together a particularly lavish mission of homage. Gifts of incomparable quality were to demonstrate the singular magnificence of his conquests in Africa and Asia, with the Far East taking the spotlight.

Precious manuscripts, Chinese porcelain, tremendously valuable fabrics richly adorned with gemstones, specially commissioned art objects decorated with Far Eastern jewels, as well as the most exotic animals were to accompany the mission as gifts. It was known in Lisbon that Leo X was not only well prepared for this last kind of gift but valued it especially. Leo X himself kept an enclosure in the Vatican to hold animals imported from all over the world. Besides a cheetah, two leopards, a Persian horse and many parrots and dogs from India, Manuel therefore chose a particularly sensational animal for the mission: a four-year-old white elephant from India, which had been well trained by its Indian keeper, or mahout, and was able to dance and perform other tricks.

An elephant was undoubtedly a particularly spectacular gift.[66] The story of this one elephant and the effect it had on its contemporaries and on following generations allows us to condense as if in a magnifying mirror all the ideas and hopes people attached to the conquest of distant countries. At the same time, the animal's fate exemplifies the lengths to which kings and popes of the time would go in the symbolic games of secular and ecclesiastical power.

Individual potentates had received elephants and exhibited them publicly on many occasions since antiquity. But events such as this were still few and far between. It was only with the discovery of the sea route to India that some Indian specimens came to Lisbon, where Manuel I kept them in a special stable. In a letter dated 6 June 1513, Manuel reported to the Pope on the success of his commander Afonso de Albuquerque in

India. Alfonso had also—here the king was full of excitement—brought elephants with him back to Lisbon. The specimen selected for Leo X was finally sent to Rome along with 43 other animals—a logistical challenge to which around 150 people were assigned. After the animals had been loaded onto a ship and the young elephant had been more or less safely secured between the masts, the journey to Italy began.

Already during the first stopovers on the Spanish coast and on the Balearic Islands, however, it became apparent that they had underestimated the attention the ship would arouse. Wherever it docked, a loud, curious throng assembled to gawk at the peculiar cargo. In the end, the captain cut the trip short and sailed directly to Porto Ercole in southern Tuscany. The stretch of roughly 130 kilometres that still remained on land turned into an ordeal for both the animal and its keepers. Everywhere onlookers pressed upon them to marvel at the elephant and the strangely dressed Portuguese. All attempts at letting the animal rest at night in villas along the way failed—instead, the owners were forced to watch in horror as their villas, estate walls and protective fences were simply destroyed by people wanting to see the animal. The documents on the subject allow us to reconstruct the traces the animal left along its journey: ruined villas, trampled gardens, and vandalized wine and olive groves lined the elephant's route. Thousands of people tried to catch at least a quick glimpse of it. This remarkable animal, a flesh-and-blood symbol of a new world, exerted an extraordinary power of attraction and made a dramatic impression on its viewers—as if today you could see a real live extra-terrestrial.

Finally, on 18 March 1514, the embassy made its festive entry into Rome, an enormous event for which the expenditure and dignitaries involved exceeded anything ever recorded in the city's annals or seen by anyone at the time. The elephant was housed in a stable at the Vatican, while the audience of the delegation was planned for the following days.

The Pope inspected the gifts that had been brought and wrote to Manuel I: "The coffers opened, all of the curious were filled with astonishment. […] For it seemed as if one's own eyes were not adequate to admire them sufficiently, and the language does not include expressions competent to eulogize them. This is not an exaggeration […]."[67]

Although Leo X was certainly impressed with the "booty from Libya, Mauritania, Ethiopia, Arabia, Persia and India", he was particularly entranced by the animal: "But it was the elephant that aroused the greatest astonishment in the whole world and also aroused memories of the ancient past, because the appearance of similar animals was quite common in the times of Ancient Rome." The booty displayed in ancient triumphal processions had primarily served to communicate world domination. As archaeologist Ida Östenberg has incisively put it, the theatrical presentation of loot and exotic animals was a way of "Staging the World".[68] Leo X saw himself as following in the footsteps of Roman emperors, who had thousands of animals presented and slaughtered in amphitheatres to demonstrate their dominion over remote regions of the world. In the eyes of the Pope, these glorious times seemed to have returned, "after our city previously lost its supremacy," as he writes. A painting by Andrea del Sarto from 1520, inspired by the gift of Manuel I, depicts Caesar receiving animals from Egypt.[69] The artwork shows that the message had got through: contemporaries considered Manuel's gifts to the Pope as a continuation of this ancient tradition.

From then on, with almost childlike joy, the Pope visited his new favourite almost every day. The elephant was named Hanno (possibly in memory of the Carthaginian seafarer who once explored the west coast of Africa) and the Pope had it perform tricks and spray him with water from its trunk to exuberant papal laughter. Until the early death of the animal, which fell seriously ill in June 1516 and, despite being treated by the Pope's best doctors, died within a few days on the 8th of that month after

little more than two years in Rome, both the Pope and the population of the city enjoyed it greatly. It is conceivable that Leo X somewhat exaggerated his love for the animal and exploited the elephant as a symbol of his "golden" papacy. Some sources report that Hanno was completely covered with gold dust for a public festival. Since a young man who had also been "gilded" as a personification of the new Golden Age had recently suffocated under his coating of gold dust in Florence, something similar may have happened to the elephant.[70]

This is uncertain, however, and the majority of sources state that Hanno died of a severe angina. The Pope was deeply distressed and decreed that the animal was to be sumptuously buried in the Vatican. No lesser artist than Raphael was commissioned to produce a lifelike fresco of the elephant, accurately depicting the size of his body and the unusual colour of his skin. When the fresco—now lost, though a fascinating draft in red chalk survives—was finally unveiled on the bell tower next to the entrance to the Vatican, this naturalistic drawing of an animal greatly astonished the Romans. Leo X further had an epitaph he had personally composed transposed into Latin hexameters by Filippo Beroaldo: "Under this great hill I lie buried / mighty elephant which the King Manuel / having conquered the Orient / sent as captive to Pope Leo X [...] That which nature has stolen away, / Raphael of Urbino with his art has restored."[71]

In the following decades, the elephant remained vividly present in the minds of contemporaries and stimulated artists to create ever more new portraits and poems. Manuel I and Leo X stayed in close contact until the end of their lives in 1521. (They died within a few days of one another: Leo X on December 1; Manuel I on December 13.) After the rich gifts Leo X sent to Portugal in return in 1514, they had continued to exchange letters, trading ideas about science, religion and the arts.

Manuel I had hit the mark with his mission of homage and above all with his rich gifts and the elephant. Leo X was able to interpret the

animal as a symbol of the new greatness of Rome, which the Vatican—as the king's embassy clearly signified—owed to the Portuguese conquests. The gifts the embassy had brought were consciously selected to reflect the wealth and extent of the new Portuguese Empire. Their presentation was accordingly accompanied by lectures delivered by the ambassadors, in which they emphasized how the conquests benefitted the Church. The speakers presented the occupation of new territories, the conversion of the local population to Christianity and the new geographical knowledge in carefully chosen words—and combined their confident descriptions with Manuel I's request for recognition and extensive concessions on the part of the Curia.

Behind the gift-laden mission of homage stood Manuel I's urgent need to defend his rule over large areas of the world against Spanish interests, especially in the recently subjugated territories on the other side of the world. In a number of bulls issued in 1514, Leo X gladly confirmed that the Portuguese were to be masters of all areas east of a demarcation line that the Portuguese and Spaniards had agreed on already in 1494. Yet the Pope, both fulfilling the king's wishes and serving his own interests, went further still and even included future successes in his promises. Cape Bojador in northwest Africa and Nam in the East Indies were not to be the final borders of Portuguese rule. The Pope's decree was to apply also "in any region or place whatsoever, even though perchance unknown to us at present".[72] This phrasing, used by Leo X on 3 November 1514 in the bull *Praecelsae devotionis*, was a direct encouragement to the king to add to the Portuguese Empire by subjugating further territories. In the eyes of the Pope, this legitimation of exploitation and rule was at the same time an obligation to missionize, allowing the Vatican to share in the success of the conquistadors not only spiritually, but, as the exchange of gifts showed, also materially.

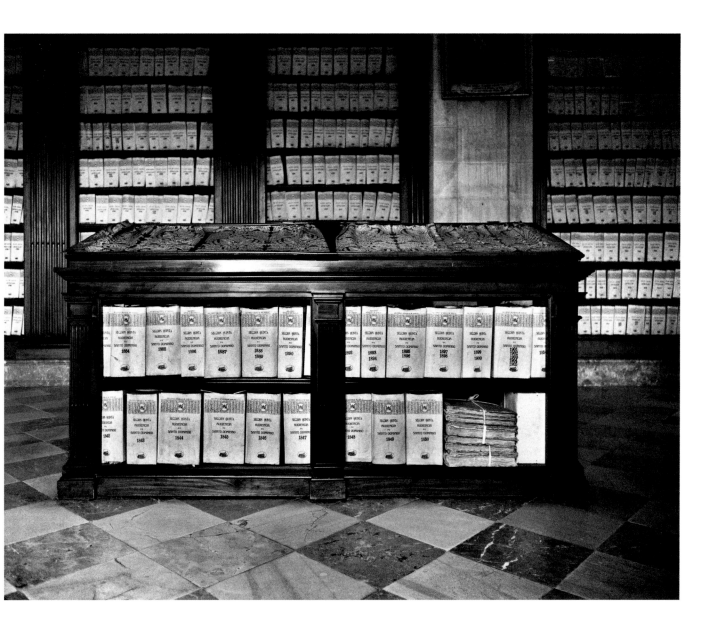

VI. Dividing the World in the Age of Discovery — The Treaties of Tordesillas

The exchange of extremely valuable gifts, the financing of opulent festivities in Rome and the planning of Portugal's further military conquests in 1514 adhered to an established tradition of coordination between secular and ecclesiastical potentates. But the staged performances, the speeches of the envoys and the letters sent by the Curia also reveal a new world order. It had been ushered in 20 years earlier by the famous and almost proverbial "division of the world" established in the two treaties of Tordesillas signed by the Spaniards and the Portuguese on 7 June 1494. It is to these agreements, which we have already mentioned several times, that we now finally turn.[73] After all, the treaties and the papal letters on this agreement have a central place in the archives of Seville. One might even say that they provided the spark that led to the writing and archiving of the thousands upon thousands of documents that would eventually find their place on the shelves in Seville.

The initiative behind the treaties was Spanish and came soon after Christopher Columbus returned from his first voyage of discovery in 1493. The Spanish royal couple Ferdinand II and Isabella wanted Pope Alexander VI to confirm their supremacy over the newly discovered countries and islands in the west. In the background were the older commitments Spain's competitor Portugal had previously negotiated from the Curia. A division of the Atlantic had already been specified at that time, albeit by a different

geographical logic. In 1454, Pope Nicholas V had granted the Portuguese the rights to all seafaring along the coast of Africa, a concession which the Spaniards finally recognized in the peace treaty of Alcáçovas in 1479. The Portuguese were thus accorded all islands south of the Canaries, and a line of latitude running parallel to the equator at Cape Bojador was defined as the border between the southern and northern Atlantic.

With the discoveries Columbus made to the west, a new situation had arisen that called for a different contractual arrangement. John II, king of Portugal, and the Spanish royal family agreed on a line that would run "de polo Ártico al polo Antártico" (from the North to the South Pole). Based on his nautical experience, Columbus proposed a north–south line located 100 nautical miles west of the Cape Verde islands. As documents in the archive of Seville show, however, the specialists from both kingdoms recommended a different solution: a line running from pole to pole 370 nautical miles west of Cape Verde and the Azores. None of this affected the agreements of 1479, which were expressly confirmed in the first of the two treaties.

The second treaty was concerned solely with the western Atlantic. The division of the world it stipulated is not the only aspect of the treaty that has attracted so much attention to this day. It is famous also for the fact that Pope Alexander VI had already taken a position on the division back in May of 1493, issuing four bulls that seem to have more or less defined the zones of influence months before the treaty was even signed. In retrospect, you cannot avoid the impression that the Curia was demonstrating its omnipotence one more time before the Reformation and the subsequent era of religious struggles began. Or, as Ferdinand Gregorovius pointedly noted in his *History of the City of Rome in the Middle Ages*, written in the middle of the 19th century: "This stroke of the pen was the last reminiscence of the universal authority of the Roman Papacy".[74]

When the treaty became known, the kings of England and France naturally reacted negatively to the Pope's letters. The king of France wrote that "the sun shines for me as for the others. I would like to see the clause of Adam's will which excludes me from a share of the world".[75] Jill Lepore, in her recent history of the United States, follows his lead when she argues that the Pope decreed a division of the world "as if he were the god of Genesis".[76]

But things are not quite as clear-cut as they may appear at first glance. The French king's letter suggests that the division of the New World was ultimately a decidedly secular matter of power politics. While older research assumed that the Pope, known for his ruthlessness, had used the documents to settle the dispute between the two parties and therefore intervened in the negotiations, the papal letters are now understood rather as a success of Spanish diplomacy. Ferdinand II and Isabella, who had decisively influenced the choice of the Spaniard Rodrigo Borgia as Pope Alexander VI in 1492, were well connected in the Curia and the papal chancellery. It is now believed that the bulls were actually formulated by the Spanish chancellery itself to give it an exceptional starting position in the negotiations with Portugal. Alexander VI merely signed the bulls and sent them only to the royal family in Spain and not to Lisbon — which is why the originals can still be seen in Seville today. By the standards of medieval law, the Spaniards had thus gained a legally binding document, since the Pope could punish any breach with excommunication.

In any case, Alexander VI was an ideal partner for the ambitious Spanish couple simply because he was particularly unscrupulous. The infamous Borgia Pope's decision back when he was elected in 1492 to call himself Alexander in reference to the ancient Macedonian conqueror was clearly designed to send a signal. The division of the world in 1494 perfectly matched the claim to world domination announced by his name, even if it was only the spiritual domination of the Church. Alexander's

contemporaries already saw his election to the papacy, achieved through simony and bribes, as a division of the Catholic world, since it had so badly split the dignitaries involved. The Pope's excessive spending and his countless love affairs provoked many critics and benefitted church reformers, including the famous Girolamo Savonarola in Florence. When Alexander VI forbade him from preaching his critical sermons in 1495, Savonarola staged the so-called "bonfire of the vanities" on the Piazza della Signoria in Florence. Books, paintings and luxury goods of all kinds were burned on a huge pyre as unchristian possessions. The excesses of Alexander VI remained unaffected, however, and Savonarola was executed in 1498 after having lost all his support in Florence.

All things considered, the Spanish crown found the Borgia Pope a suitable partner, who issued what the Spanish drafted as his own *litterae apostolicae*. In 1494, it was thus a matter of ratifying what these papal documents already stated through tough political negotiations. Seen in this way, the diplomatic tangle seems pretty easy to understand. But one last, not insignificant detail may still confuse us. Nowadays, thanks to the omnipresent internet, we are used to having clear geographical coordinates and being able to find our bearings anywhere every day of our lives. Given the immense impact the Treaty of Tordesillas had upon world history, it is all the more surprising that the men who so confidently divided the world into two hemispheres had at best a flawed understanding of what they were doing.

For one thing, the geographical stipulations of the treaty were far from clear. The parties had no concrete knowledge of exactly where the line was that they were drawing from pole to pole 370 nautical miles west of the Cape Verde islands. This was essentially due to the fact that the geographers, cosmographers and nautical specialists of the time were able to calculate lines of longitude (meridians) only in theory. Seafarers sailing from an actual port could not navigate precisely by or to

these lines out at sea. The treaty was marking a line in a space that was geographically largely undetermined. The contracting parties therefore agreed that within ten months both would send out ships manned with captains, seafarers, astronomers and other experts to determine the line as precisely as possible—in other words, to finally map it. At the same time, the order was given to erect immovable markers in the shape of towers and boundary stones on any islands or landmasses they might find located on the line.

These ships, however, never sailed. In an addendum to the treaty dated 7 May 1495, the parties agreed to set up a commission to draw the line on a map. This map would then serve as a template, on the basis of which the same modification would be made to all nautical charts. This too proved unsuccessful. Nevertheless, a few years later, two maps existed that showed the line for the first time—a map by Juan de la Cosa (1500) and a Portuguese map, for which we owe our knowledge to Alberto Cantino, who succeeded by means of bribery in bringing a copy made in 1501/1502 (the so-called Cantino world map) to Italy.[77]

As the voyages of discovery and conquest touched on more and more new regions and border disputes began on the other side of the globe, the continued uncertainty about where the dividing line ran on Earth came to be recognized as a growing problem. Portugal had been firmly established in the trade with India since 1511, but Magellan's circumnavigation of the world in 1520 soon allowed the Spaniards to enter the region from the east. From then on, the colonial powers were constantly vying for control of the area. Magellan had in fact been tasked not merely with refuting Portugal's claims of ownership upon arriving in India but also with conquering Malacca, which was controlled by the Portuguese. While he did manage to establish a Spanish trading base in the Moluccas, he could not reliably prove that it belonged to the Spanish hemisphere defined by the Tordesillas line.

Another conference was convened, the so-called *Junta de Badajoz-Elvas* of 1524, which once again brought together experts from different disciplines and with divergent interests. Badajoz was a town on the border between Castile and Portugal (as was Elvas on the Portuguese side), a setting chosen because the negotiating delegations on both sides were forbidden from taking maps out of the country, as they contained state secrets about their explorers' discoveries. One attendee was the illegitimate son of Columbus, Hernando Colón, who was not only a leading cosmographer of the time and considered himself the keeper of his father's ideas about cartography, but had also built up a large library in Seville, comprising up to 15,000 volumes.[78] The records of this conference impressively reflect how difficult it was to come to an agreement. The participants could not even agree on how to convert nautical miles into degrees of longitude. Nor did each side trust the other side's charts, especially since these were based on nautical experiences kept secret in their respective archives.

As contemporaries were well aware, maps at the time were not reliable topographical representations, but "historical paintings" or "decorative versions that served [...] representational purposes".[79] To remedy this, someone even suggested that they start with a white globe ("una poma blanca") and paint in only those countries the location of which they could agree on. But even questioning seafarers, especially those who had sailed with Magellan, did not help them. The meeting in Badajoz was unsuccessful, and the globe remained largely white.

It was only with the Treaty of Zaragoza, concluded in 1529, that Spain and Portugal finally reached an agreement. Its basis, however, was not a reliable map produced by experts but simply a great deal of money. The Spanish king, Charles V, who was always in need of money for his many travels and campaigns, sold the trading rights with the Moluccas to Portugal for 350,000 gold ducats. A commission was then set up to draw the

demarcation line on two identical maps that were to be used as a binding model for all nautical charts. The Spice Islands were now in the hands of Portugal. Needless to say, even this attempt at fixing the dividing line on a topographical map ultimately failed. The disputes over the exact course of the line agreed upon in Tordesillas continued into the 18th century.

In the end, what remained valid was what a clever lawyer had written in a letter to the Spanish king a good ten years before the Treaty of Zaragoza. The Spanish investigating magistrate and later governor Alonso de Zuazo, who had been commissioned to determine the course of the line in Brazil, described, for the first time and with great acuity, how the drawing of the line and its great impact upon world history were inseparable from its purely imaginary existence:

"One knows the concession of Pope Alexander: the division of the world like an orange [*la división del mundo como una naranja*] between the King of Portugal and the grandparents of His Majesty, by means of certain imaginary lines that were not drawn. Though pilots were sent out to determine a border and this line in the right place, since it is a division on a degree of longitude, which does not help the pilots and about which they do not understand anything, they were neither able nor in a position to make a reliable determination. And so they came back having accomplished nothing."[80]

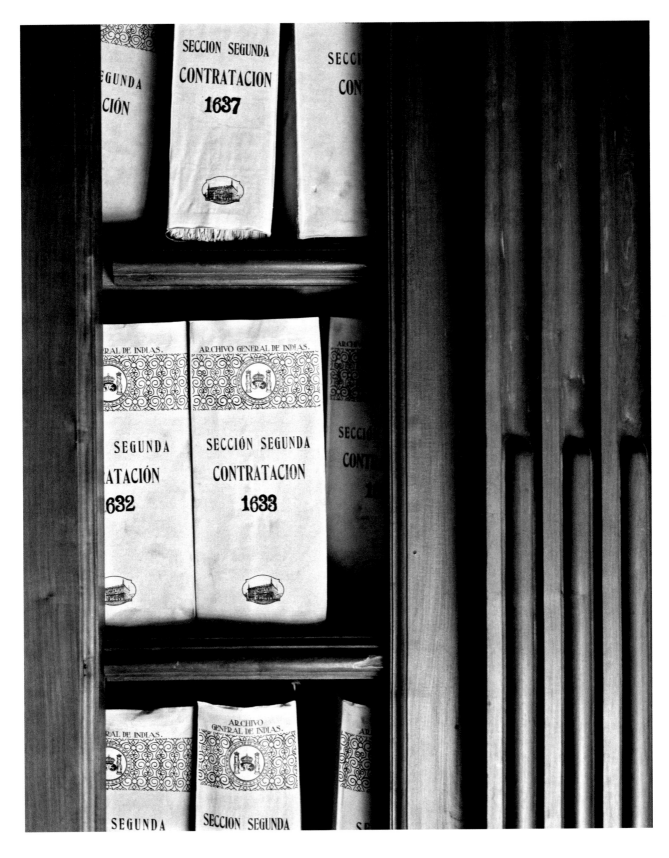

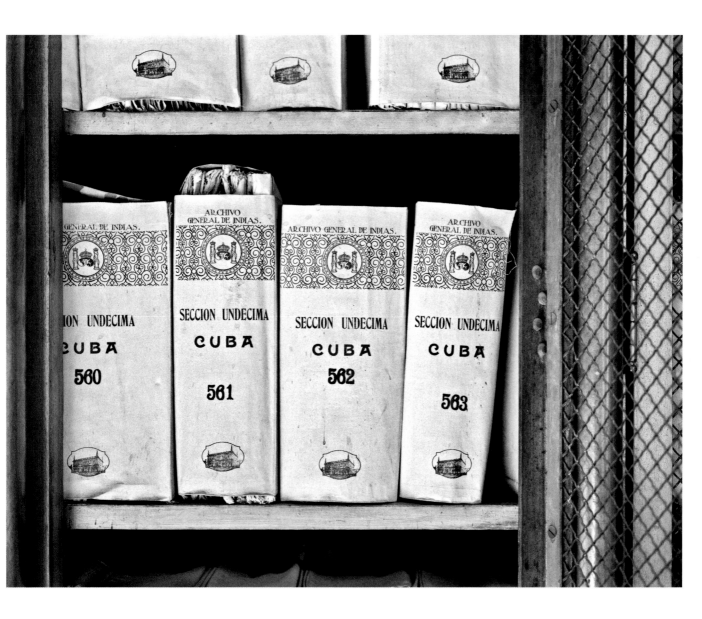

VII. The Earth as a Whole?

The division of the world under the Tordesillas Treaty had far-reaching political implications.[81] What seemed like a clear matter on paper was difficult to enforce in reality. With the discovery of the sea route to India, the occupation of the Moluccas and finally Magellan's circumnavigation, the dispute now had to be fought out in the other hemisphere as well. How was one to pinpoint a line in the Indian and now also the Pacific Ocean that had already proved impossible to draw between Europe and America?

Both the basic knowledge and imaginative power required to accomplish this were lacking. In the 15th century, few disputed that the Earth was spherical. But the rediscovery of the works of the ancient geographer Ptolemy (2nd century CE) had popularized his geographical localizations and calculations of the globe's circumference. In place of Eratosthenes' very precise calculation of the Earth's circumference in the 3rd century BCE, the cosmographers of the late Middle Ages hence accepted the erroneous calculations of the later scientist, which underestimated the width of the Atlantic and overestimated that of the Mediterranean. The famous first globe made by Martin Behaim in 1492, which did not yet record the newly discovered lands, reflected these faulty calculations, since it was based on a map drawn in 1482, which in turn used the figures given by Ptolemy.

Columbus himself had used Ptolemy's incorrect calculations and a remark by the geographer Strabo about the navigability of the Atlantic to

convince his clients that his expedition had a good chance of success. His diaries and letters from his third voyage in 1498 show how fuzzy Columbus's ideas about the Earth really were and what childlike fantasies he attached to it. He wrote: "After I got to the height of the line [of the treaty of 1494], I encountered a very mild temperature of the sky and as I pushed forward, this intensified. [Due to the different heights of the north star] I came to believe that the world is not round in the way they write, but has the shape of a pear, meaning that it is round, except where the stalk is [...]."[82] In one place, Columbus says in a letter, "something like a woman's nipple" protrudes from the ball. In his imagination, this nipple area is the newly discovered land, in the middle of which "the earthly paradise" is located. In making these statements, Columbus may well have been influenced by ancient notions of Elysium, the Isle of the Blessed, which was thought to be located in the far west.

In contrast to this apparently childish joy of discovery, the Spaniards and Portuguese had to ensure that their maps of the new areas were as precise as possible. After all, they promised power, wealth and the ability to organize trade on an unprecedented scale—and the dazzling prospect of goods to plunder and locals to enslave. Accurate maps were essential in defining maritime spheres of influence and opening up new trading areas.[83]

The officials of the Casa de la Contratación, founded in Seville in 1503 to ensure complete control of the colonial areas, quickly saw the need to act. The large number of contradictory nautical charts were to be replaced with more reliable data. On 6 August 1508, on the king's initiative, it was decided to place all material gathered in Seville under central administration. A master navigator (*piloto mayor*) was to be appointed, whose tasks were described as follows: "Since we were told that there are many templates for maps by various masters [...] that differ greatly from one another, both in terms of the courses and the location of the areas, and that this can cause great evil and so that order may be kept in

everything, it is our wish and we command that a *padrón real* be made".[84] In this *padrón real*, a kind of (royal) master chart, all currently available and future information was to be combined in order to gain a clearer understanding of the geography and to facilitate planning. The map and the picture of the world drawn on it were also to be used for the accurate collection of customs and taxes, bringing together the experiences of the seafarers and the financial interests of the crown. The *padrón real* ultimately consisted of a large number of maps, reports, notes by returning travellers and similar forms of useful information. The contradictory experiences and reports of the seafarers that had led to inconsistent maps were now replaced with a general nautical chart, centrally drawn up with the help of cosmographers and administrative specialists, and capable of providing reliable orientation and knowledge.

Beyond the centralized administration of Spanish mapping by the Casa de la Contratación and later by the Council of the Indies, there was a growing general interest in world maps, globes and geographical literature at the beginning of the 16th century. With the world map he created in 1507, the German cartographer Waldseemüller had issued "a birth certificate for the world [and] a death warrant for the one that was there before".[85] In public institutions and upper-class residences alike, globes were now set up and maps hung on the walls. At court, these objects were a means of representing one's power in spatial terms. A famous example is the tapestry made by Bernard van Orley in Brussels in 1525 for the wedding of the Portuguese king, John III, and his wife Catharine—just when the division of the world was being argued about in Badajoz. The tapestry shows the half of the globe claimed by Portugal, with the Moluccas and Malacca visible in the east. The royal couple, who flank the globe, hold their right hands over it, symbolically laying claim to the space shown. By contrast, Spanish maps of this period show the Spice Islands in the west. All are visual expressions of colonial power politics.[86]

The Tordesillas treaty marked the "beginning of a global view of the world".[87] But it was a global view built on a division of the world, and this division was to be a continuous concern throughout the following decades. While most efforts went into ascertaining as much as possible about the demarcation line established in the treaty, the competing claims to various territories also continued to fuel the production of competing images of the globe and the affiliations of the countries shown on it.

Around 1600, the way the world was visualized on maps definitively submitted to geography and actual topography. Medieval traditions of cartography faltered. On their *mappae mundi*, medieval cartographers had been used to placing countries, cities, rivers and seas based on their importance in biblical stories and salvation history. Jerusalem, where the redemption of humanity through the death of Christ had taken place, was frequently chosen as the centre of the world. The Ebstorf map from the 13th century is probably the most impressive testimony to this perspective. The entire world, centred on Judea, is held by Christ, whose body encompasses the world, with parts of it visible at the top (head), the edges (hands) and the bottom (feet). With the Portuguese and Spanish expansion, cartographers gained new geographical knowledge that allowed them to go beyond the ancient texts. When the monk Fra Mauro drew a map of the world in a monastery near Venice in 1459, he was no longer just combining information from Arab and ancient cartographers. For his illustration of the whole world, drawn by order of the Portuguese king, Afonso V (1432–1481), in which Jerusalem was now relocated from the centre into the west, he also incorporated maps from Venetian and Portuguese sailors, which King Afonso had made available to him, probably to stake out his claims to the African coast. To this day, Fra Mauro is considered a pioneer of a form of cartography that took a new look at the world as a whole in the 15th century. And given what has been said of the "overview effect" (see Chapter II), we may note in

passing that in 1971 the Apollo 14 mission landed in a lunar crater named after this Venetian monk.

Fra Mauro and the cartographers who followed him witnessed new expeditions that made older ideas of the world obsolete and called for ever more new mappings of the whole world. The image of the world shown on maps and globes after the treaty of 1494 was no more than a hypothesis that had to prove its worth for navigation and colonial administration and had to be corrected continuously. The uncertainty about where exactly the new countries and islands were to be entered on a map was only the tip of an iceberg of ignorance. In practice, the king's difficulties in obtaining trustworthy information about the colonial territories themselves, their inhabitants, numbers, modes of organization, areas of cultivated land and potential tax revenues were far more serious — and the archive in Seville holds much in the way of such practical information. The New World was dominated by the competing interests of many different parties and people, including loyal and disloyal officers of the king. What information did reach the court was invariably coloured by self-interest. This explains the attempts made to centrally monitor and control all aspects of colonial rule down to the appointment of every single captain. The result was a constant traffic of requests and demands for information from the central administration. The overwhelming flood of paper this "paper empire" produced filled the archives for about 250 years, until eventually an astounding 90 million documents found their (as of now) final home in Seville in 1785.

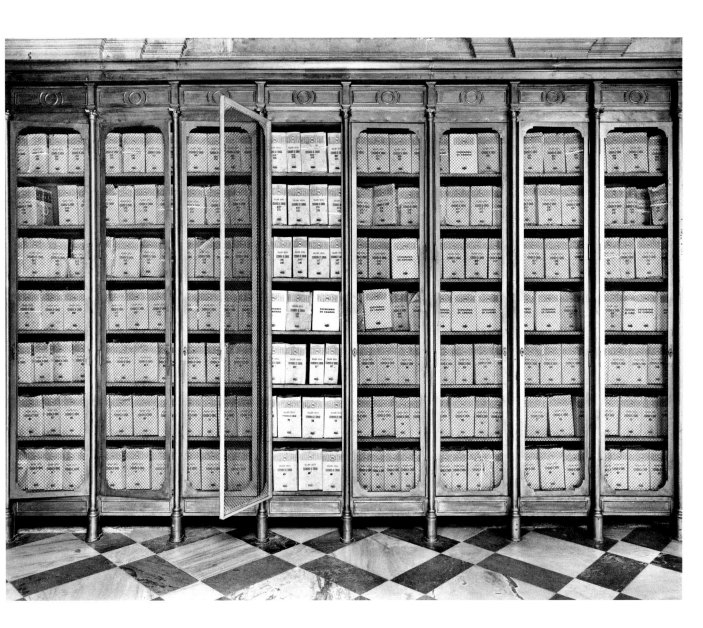

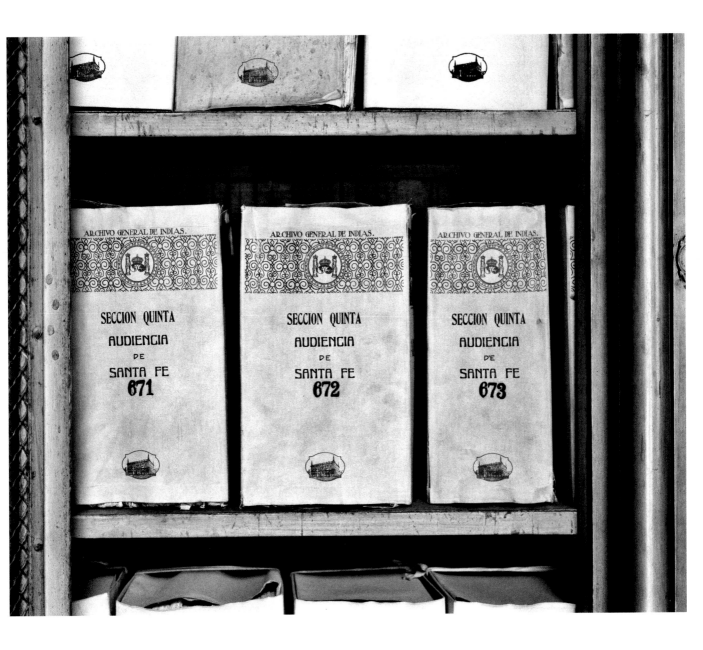

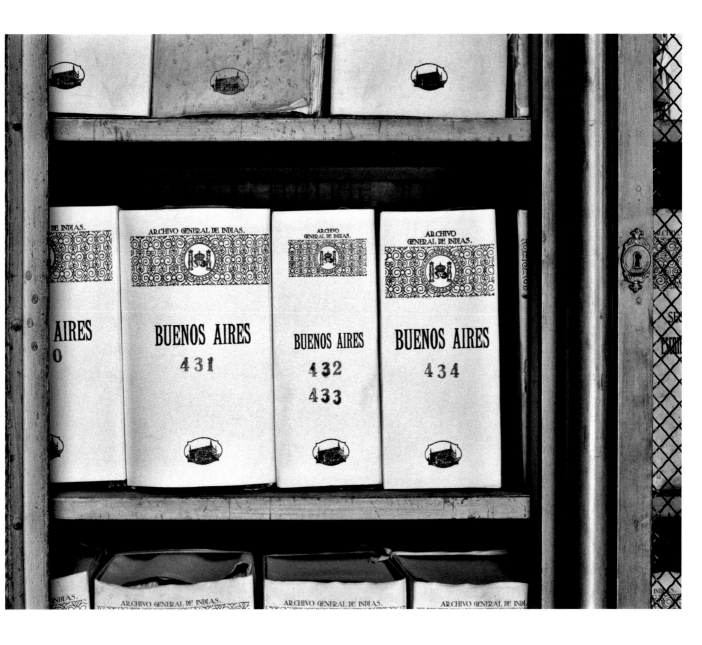

VIII. The Splendour of Rule, Humanitarian Disasters and Voices of Warning

"Ego vox clamantis in deserto" —
"I am the voice of the preacher in the desert"
Antonio de Montesinos: sermon on the 4th Sunday of Advent, 1511[88]

Spain was undoubtedly the greatest power of the 16th century. After the Portuguese royal family died out in 1580, the Spanish king, Philip II, was even able to assert his right to the crown of Portugal, forcing the country to accept the Spanish king as its head of state. At the same time, however, Spain was already severely stricken by military disasters, the loss of the northern Netherlands and England's defeat of the proud Spanish fleet (in the king's words the *Armada Invencible* or *Grande y Felicísima Armada*) in 1588. The sheer luxury on display in Spain at this time had long since awakened the desires of other naval powers. The 17th century was to be the era of the Netherlands and England, whose privateers, including Francis Drake and Henry Morgan, would severely damage Spanish trade in the Atlantic. As we saw earlier, England had not accepted the bull of Alexander VI on the Treaty of Tordesillas since the king of England, and not the Pope, was the head of the Anglican Church.

While the Thirty Years' War plunged large parts of Europe into chaos, however, the Iberian Peninsula enjoyed a time of relative calm, with the Spanish Empire exhibiting remarkable internal stability in this time of

turmoil and transformation. This was also a period of tremendous artistic productivity, a golden age of fine art and painting brought about by Diego Velázquez and others. The residences of the well-to-do now amassed art collections that far outstripped anything previously seen in Europe.

The grand royal buildings constructed in this period were equally remarkable. The strictly symmetrical palace and monastery complex of El Escorial near Madrid symbolically expressed Philip II's notions of the rationality of global Spanish rule.[89] The magnificent complex, designed by Michelangelo's pupil Juan Bautista de Toledo and completed by Juan de Herrera, was considered a modern wonder of the world, though it served primarily ceremonial purposes from 1598 onwards, as well as providing the burial place of the Spanish kings into the 20th century. It was the largest Renaissance building in the world. The merchants' exchange in Seville, which was built and expanded up to the mid-17th century, likewise made a truly monumental statement of the magnificence of Spanish rule, especially as it was framed by the Royal Alcázar and the grand cathedral (the third largest church in the world).

The kings' building policy, the centralized surveillance of the newly conquered countries and the archival recording of all related administrative acts are all impressive forms of monarchical symbolism, which continue to attract crowds of tourists to this day. What these architectural and textual monuments of sovereignty conceal are the devastating experiences of the native peoples of the New World and much of Africa. Their suffering was due, in part, to the streams of migration now moving from east to west: in the 300 years from 1500 on, two and a half million Europeans settled in the New World. Thirteen million enslaved Black people were transported to the Americas as well. Around 50 million of the original inhabitants fell victim to the new diseases introduced by Europeans during this period.[90] Particularly devastating were those viruses and bacteria to which Europeans were already resistant from living in heavily

populated and dirty cities, but to which America had not been exposed until the conquerors arrived. After a few generations, the majority of the local population had fallen victim to smallpox, measles, malaria, typhoid, bubonic plague and other diseases. The conquerors interpreted this as a sign from God. The sickly frailty of the infected showed that "God wishes that they yield their place to new peoples".[91]

Other consequences quickly became apparent in the fauna and flora. The exchange of goods between the New and the Old World was characterized by a double asymmetry already remarked upon by contemporaries. While precious metals and valuable goods were transported eastwards, all kinds of farm animals and seeds of plants for cultivation were shipped west into an entirely different ecosystem. As stowaways in this cargo came the seeds of weeds, which spread furiously across farmland now being cultivated with previously unknown plants. The pigs the Spaniards brought as provisions quickly became the dominant source of meat and were soon to be encountered everywhere, causing many to see them as pests.

The dramatic consequences of conquest for the local population became obvious only a few years after Columbus's voyages. As early as 1504, the Spanish king's scholars had assured him that his brutal and violent policy of conquest was legal. They quoted the ancient philosopher Aristotle in support, since he had professed in his *Politics* that people are divided into those that rule and those that are owned by others and are therefore to be treated as slaves by their very nature.[92] As such, they were not entitled to possess any property and could not lay claim to a country of their own.

Such learned discussions, intended to legitimize slavery and conquest, contrasted starkly with the terrors of everyday life in the conquered territories. The horrors provoked intense criticism, especially from some of the believers who had journeyed there as missionaries. The sermon

given by Dominican Father Antonio de Montesinos on La Española in December 1511, on the fourth Sunday in Advent, has become famous. In a simple yet effective fashion, he called into question the rights the scholars had granted the king: "Say, with what right and with what justice do you keep those Indians in such a cruel and terrible bondage? Who gave you authority to conduct such despicable wars against these people who quietly and peacefully lived in their homeland, of whom you have wiped out countless numbers by outrageous acts of murder and violence? How can you suppress and plague them without giving them food or caring for their illnesses, which they contract through the excess of work that you impose on them and let them die — or, more clearly put, kill them to dig and barter for gold every day? [...] Do they not have souls imbued with reason? Are you not obliged to love them like your own self?"[93]

In 1552, Bartolomé de Las Casas reported on Montesinos' sermon in his *Brevísima relación de la destrucción de las Indias occidentales* (A Short Account of the Destruction of the Indies) and recorded the text from memory. He himself changed his attitude under the impression of this sermon in 1514 and from then on prominently advocated for the rights of the indigenous people. After 1516, he drew attention to this humanitarian tragedy in three memoranda: "And so it happened that the Indians, ill-treated and even worse-provisioned and worked to the bone, have been reduced from the one million souls there were on La Española to fifteen or sixteen thousand, and they will all die if help is not given quickly".[94] In 1516, the king appointed him protector of the "Indians", whose rights he was to uphold before the Council of the Indies. His options, however, were limited. Although Ferdinand II had already in 1512 enacted the laws of Burgos (*Leyes de Burgos*) to control and limit the oppression of the natives, he had previously treated protests from the Dominicans with contempt, telling them they ought to read the bulls of Pope Alexander VI through first before they protested to him. In Ferdinand's view, the *encomienda* system

(which turned the indigenous population into forced labour for the colonists) was legal "thanks to papal grace and grant, and compatible with divine and human law"—as a commission of theologians and lawyers had confirmed in Burgos.[95]

Despite several waves of suicide among the natives, the conquistadors and Spanish settlers insisted on their servitude to the colonists. In 1513, the court found a deeply hypocritical way of legitimizing the oppression of the "Indians", with the king ultimately acquiescing to what the Spaniards wanted: from now on, the colonisers were to read out the so-called *requerimiento* to anyone they wished to subdue. After stating that all people were created by the Christian God, this document goes on to say that—in accordance with the biblical creation story—you shall "acknowledge the Church as the Ruler and Superior of the whole world, and the high priest called Pope, and in his name the King and Queen". If you refuse, "I certify to you that, with the help of God, we shall forcibly enter into your country, and shall make war against you in all ways and manners that we can, and shall subject you to the yoke and obedience of the Church and of their Highnesses; we shall take you and your wives and your children, and shall make slaves of them, and as such shall sell and dispose of them as their Highnesses may command."[96]

Armed with this document, the Spaniards marched on, subjugating the Aztecs and other peoples. People continued to criticize the crimes being committed, however. Francisco de Vitoria, a professor of theology at the University of Salamanca, became the next prominent protagonist in the struggle. Late in 1538 or very early in 1539, he gave a lecture entitled *De Indis*, which drew much attention and deeply enraged Charles V.[97] The point he debated was whether the children of infidels should be baptized against the will of their parents. What was so explosive about this theological question? Its answer depended on whether one recognized the sovereignty of the king or that of the Church at all and whether it had any

legal basis. The reports sent by missionaries certainly revealed gross injustice: "[…W]hen we hear of so many massacres, so many plunderings of otherwise innocent men, so many princes evicted from their possessions and stripped of their rule, there is certainly ground for doubting whether this is rightly or wrongly done."[98] De Vitoria believed that theologians were called upon to address the question of how to deal with the "Indians". Implicitly, he indicates that the king's lawyers and the theologians who had so far been involved, including those at Burgos, had not found a workable solution for the natives — as was apparent from how little effect the laws of 1512 had had, even after 30 years.

De Vitoria proved that the natives were not slaves on the Aristotelian definition when the conquerors found them: "Therefore, unless the contrary is shown, they must be treated as owners." Their unbelief did nothing to change that. In the second section of his lecture, de Vitoria states that the emperor cannot be the lord of the whole world, because "that dominion must be founded either on natural or divine or human law; but there is no lord of the earth in any of these."[99] He also declared that the proposition that the Pope was the sole ruler in the temporal domain all across the world and consequently had been able to invest the Spanish kings as rulers over those "barbarians" was wrong. The Pope had no temporal power over the "Indian barbarians", only authority in the spiritual realm. This was not sufficient to justify the right to "wage war on them". There was also no comprehensive right of disposal arising solely from the discovery by Columbus (*iure inventionis*) nor did unbelief justify such treatment of the "barbarians". De Vitoria hence expressly denied that the *requerimiento* was legal.[100]

In his view, the natives "undoubtedly had true dominion in both public and private matters" before the Spanish arrived. They had reason "because there is a certain method in their affairs, for they have polities which are orderly arranged and they have definite marriage and magistrates, overlords, laws and workshops, and a system of exchange, all of

which call for the use of reason; they also have a kind of religion." If they appeared to lack reason, then "I for the most part attribute their seeming so unintelligent and stupid to a bad and barbarous upbringing, for even among ourselves we find many peasants who differ little from brutes." While his remarks on the stupidity of Castilian farmers and agricultural workers seem contemptuous, de Vitoria's main aim was to prove that no one would ever doubt that the Spanish peasants were indeed human. And he recalls Aristotle, who "certainly did not mean to say that such as are not over-strong mentally are by nature subject to another's power".[101]

In this exhaustively argued lecture, which runs to around 85 pages in modern print editions, de Vitoria's central aim in the winter of 1538/39 was to obligate the Spaniards to deal with the natives as equal partners. Being among them, trading with them and doing missionary work were perfectly acceptable, but no right to subjugate and use violence derived from these interests. All dealings with them ultimately needed to recommend Christianity as a faith. Christian conquerors should under no circumstances act in ways that made Christianity appear a religion of violence and misanthropy. Any such mission would be ineffective, though he did allow that if a mission were actively opposed, resorting to violence would be lawful. But it must remain the *ultima ratio* in all matters.

De Vitoria's lecture, which discusses a wide range of moral and legal problems and provoked a lively discussion among lawyers and theologians, remained without parallel in other European countries until the 17th century. His ideas of a community of nations and of an international law that relied on communication among equals are found in no other 16th century scholar. This is impressive even if one takes into account that, as with Las Casas, it did not occur to him to view the differences between cultures in a positive light. His arguments that the natives ruled their territories legitimately and that papal and royal claims to power over them could not be justified were outrageous in his time.

Charles V's reaction was predictably forceful. In a letter addressed to the prior of San Esteban in Salamanca on 10 November 1539, he complained that, besides the university masters, other people had also contested the king's claim to rule across the Atlantic and the Pope's right to confirm his claims. He demanded that these people be questioned under oath and without delay. They were to make statements that were to be sent to the king and all documents in which the authors had expressed themselves in this vein were to be confiscated. Any trace of this debate was to be wiped out. This apparently put so much pressure on de Vitoria that he refrained from publishing his lecture. His arguments, which survived in various manuscripts, were kept safe by his students and finally printed in Lyon in 1557, 11 years after his death.

De Vitoria was an intellectual ally and significant trailblazer for Las Casas, whose book on the Spanish atrocities was receiving widespread attention almost at the same time as de Vitoria's lecture finally appeared in print.[102] It aroused great interest in Protestant England, for example, where it was published under titles such as *Spanish Cruelties* or *The Tears of the Indians*. When, at the end of the 16th century, the English decided to take a stand against the Spaniards in America, they quickly developed divergent notions of the indigenous people—and thus, without realizing it, adopted the essentials of de Vitoria's thinking. In English letters and travelogues, the "Indians" were presented as people who lived in a kind of golden age. As Jill Lepore points out, this made the natives appear as if they were the mythical ancestors of the English themselves "and the New World was the oldest world of all"—as John Locke had already noted when he observed: "In the beginning all the world was America."[103] Land was now to be appropriated somewhat differently, guided by notions of human equality and with genuine colonial settlements replacing conquest for the purpose of exploitation. It goes without saying that the North American indigenous peoples were likewise soon mistreated, brutally

fought in the Indian Wars until the 19th century, and finally forced into reservations. And while new perspectives did open up 100 years after the Spanish conquest, in retrospect, these too belong to the "world-historical tragedy", as Bernd Roeck calls the age of international competition that began with the voyages of discovery: "Holy wars intertwined with struggles for worldly power."[104] And yet Jill Lepore can open her new history of the United States of America by combining a bleak diagnosis with a brighter outlook: "The nation's founding truths were forged in a crucible of violence, the products of staggering cruelty, conquest and slaughter, the assassination of worlds. The history of the United States can be said to begin in 1492 because the idea of equality came out of a resolute rejection of the idea of inequality [...]. Against conquest, slaughter, and slavery came the urgent and abiding question, 'By what right?'"[105]

The "New World" inspired numerous printed books and its discovery and exploitation can, from a modern vantage point, no doubt be described as a media event. In the context of the religious struggles that had been raging since the 16th century, however, it had also become the subject of religious competition. We have already heard about Bernardino de Sahagún's extraordinary ethnographic work and its fate. But not only texts in Aztec languages fell victim to the Inquisition. Books published in Protestant parts of Europe that described and illustrated horrific Spanish atrocities—and to contemporaries this always meant Catholic atrocities—were also banned in southern Europe and destroyed by the ubiquitous Inquisition. Nimble publishers like Theodor de Bry edited and illustrated works for both markets. The north he supplied with pictures of Spanish atrocities, which he left out in the south, thus successfully circumventing the Spanish Inquisition.[106] This mentality is well illustrated by the first Latin translation of Bartolomé de Las Casas' *Brevísima relación de la destrucción de las Indias*, published in Frankfurt in 1598 with 17 engravings by de Bry. In their brutality and depiction of violence, the

latter fulfilled the public's wildest dreams. For example, de Bry illustrated descriptions of excruciating executions: "They usually dealt with the chieftains and nobles in the following way: They made a grid of rods which they placed on forked sticks, then lashed the victims to the grid and lighted a smouldering fire underneath, so that little by little, as those captives screamed in despair and torment, their souls would leave them."[107]

All of a sudden, we find ourselves among ancient images of violence.[108] The invention of this grill was attributed to the Sicilian tyrant Agathocles. Later, around 400 CE, the Christian poet Prudentius told of the same torture device to contrast the brutality of Roman persecutors with the bravery of Christian martyrs, who endured the agony on the grill with relish since they could expect to live on in the afterlife.[109] In the early travelogues, terrible mythical creatures known from ancient texts illustrated the strangeness of the New World. For some decades, it seemed as if the conquerors themselves had mutated into those brutal monsters, whose contemporary atrocities could in their turn be illustrated perfectly with ancient images.

But the scholars went one decisive step further. In various ethnological studies, the "Indians" were now identified or compared with the people of antiquity. Field studies among the natives in America also made it easier to understand the ancient reports and to expose many an element as fictitious. Accounts of the natives and ancient accounts of foreign peoples — as well as distinctive rituals like human sacrifice — could be related to each other to improve scholars' understanding of both. In this way, a new form of cultural comparison emerged. What Las Casas had pioneered, Joseph-François Lafitau deepened and adapted in his detailed comparison of these cultures, published in 1724 under the title *Mœurs des sauvages amériquains, comparées aux mœurs des premiers temps* (The customs of American savages compared to the customs of earlier times). In the new reports, Lafitau saw "footprints of remote antiquity." As such, the "ancient

writers [...] gave him some light," while "the habits of the savages were also conducive to understanding much of what the ancients note in their writings all the more easily."[110]

Both types of report, the ancient and the modern, could be exposed as fictions. Ancient reports of alien worlds had accompanied the travellers of the Renaissance as cultural baggage for centuries, apparently helping them to get their bearings, and were gratefully repeated. This had the added benefit that kings and popes believed that these crude pictures of other worlds and their inhabitants permitted them to forgo any ethical or moral considerations in subjugating them. In exchanging precious objects among themselves, the mighty reassured one another that this attitude was righteous and enjoyed the festivities and indulging in the wealth they were gaining as a result. Their patronage of the arts and investments in monumental architecture mirrored these power fantasies and under-scored their claim that all their subjects, even if they had no access to this life, could at least share in their wonder.

As the examples of Las Casas, Montesinos and finally Lafitau have shown, there were unintended side effects. To the chagrin of the kings, honourable churchmen and missionaries spoke up, men who, unlike many of their fellow believers, could no longer bear to idly watch the suf-fering and misery of millions of dying natives. Their impressive texts were thorns that penetrated the festal robes of rulers and churchmen alike. Their texts could be ignored for a time or even concealed by imposing restrictions, but their spread developed its own momentum, so that ever more voices began to speak out, demanding humanity.

Ultimately for them it was a question of humans encountering one another as humans. The conquerors seemed to them to be acting no better than the natives they so reviled. In the eyes of these scholars, the Europeans themselves hardly differed from the so-called savages in their many atrocities. At the beginning of the 16th century, for example,

Michel de Montaigne emphasized that if one sought unbiased reports from the "New World", "we should either have a man of irreproachable veracity, or so simple that he has not wherewithal to contrive, and to give a colour of truth to false relations, and who can have no ends in forging an untruth." Then one would find that "there is nothing barbarous and savage in this nation, by anything that I can gather, excepting, that every one gives the title of barbarism to everything that is not in use in his own country."[111] While we Europeans were permitted to "call these people barbarous, in respect to the rules of reason, but not in respect to ourselves, who in all sorts of barbarity exceed them." Just as the natives might seem strange to us in their deeds, the conquerors appear alien to them in their extremely brutal methods of execution, in which they relish in the agony of their enemies: "I am not sorry that we should here take notice of the barbarous horror of so cruel an action, but that, seeing so clearly into their faults, we should be so blind to our own. I conceive there is more barbarity in eating a man alive, than when he is dead; in tearing a body limb from limb by racks and torments, that is yet in perfect sense; in roasting it by degrees; in causing it to be bitten and worried by dogs and swine (as we have not only read, but lately seen, not amongst inveterate and mortal enemies, but among neighbors and fellow-citizens, and, which is worse, under color of piety and religion), than to roast and eat him after he is dead."[112] This juxtaposition of atrocities, which made the "Old World" appear much darker than the "New", should be seen as an attempt by Montaigne to advocate for friendly coexistence between the "Old" and the "New World" and stimulate work on a common project of humanity. When in 1584 Walter Raleigh sent a first expedition to North America on behalf of Queen Elizabeth, he not only gave the seafarers a copy of Las Casas' history of the Spanish atrocities, but also encouraged them to read Michel de Montaigne, whom he greatly admired.

Montaigne's words show with great clarity how a simple adaptation of ancient narratives, as had occurred during the early voyages of discovery, became obsolete in the Age of Enlightenment. Increasingly, the ancient texts were now read with a fair dose of scepticism, scepticism that gradually helped Europeans also see the inhabitants of the "New World" in a new light.

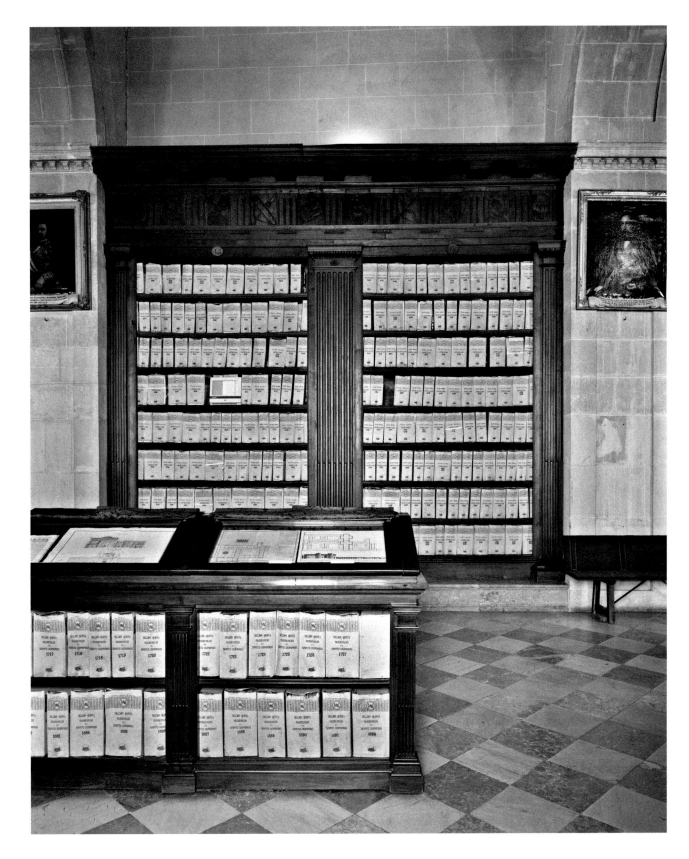

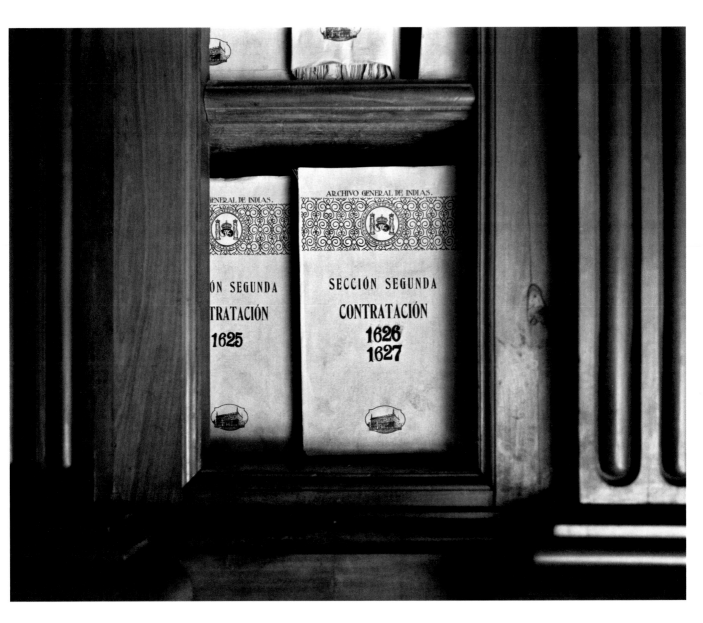

Endnotes

It is difficult to overstate the sheer volume of literature that exists on the topics addressed in this text. It was neither possible to consult everything one might have wished to, nor is it possible to list everything that was consulted. These endnotes give at least those books to which I owe important insights and notable quotations. I thank Arndt Brendecke, Christine Depta, Henry Heitmann-Gordon, Michael Hochgeschwender, Elisabeth Hüls, Viola Muraro and Paul Otting for lending their eyes and offering critical remarks.

1 See Martin Zimmermann: "Ganz nah am Menschen – Reisen, Zeiten, Orte, Spuren", in: Ursula Schulz-Dornburg: *The Land in Between. Fotografien von 1980–2012*, ed. by Martin Engler, Mack Books: London 2018, pp. 265–273.

2 Siegfried Kracauer: "Photography", in: idem: *The Mass Ornament. Weimar Essays*, translated, edited and with an introduction by Thomas Y. Levin, Harvard University Press: Cambridge, MA 1995, p. 47–63, here p. 54f.

3 Braulio Vázquez Campos (ed.): *El viaje más largo: La primera vuelta al mundo*, Acción Cultural Española: Madrid 2019.

4 Achille Mbembe: "The Power of the Archive and its Limits", in: *Refiguring the Archive*, ed. by Carolyn Hamilton et al., David Philip Publishers: Cape Town 2002, pp. 19–27.

5 See generally: José María de la Peña y Cámara: *Archivo General de Indias de Sevilla. Guía del visitante*, Dirección General de Archivos y Bibliotecas: Madrid 1958; Pedro González García (ed.): *Discovering the Americas. The Archive of the Indies*, Vendome Press: New York/Paris 1997.

6 Antonia Heredia Herrera: *La Lonja de Mercaderes. El cofre para un tesoro singular*, Diputación Provincial de Sevilla: Sevilla 1992.

7 Antonio Ballesteros Beretta: "Juan Bautista Muñoz: la creación del Archivo de Indias", in: *Revista de Indias* 4:2 (1941), pp. 55–95.

8 The two main targets were the books by William Robertson: *History of America*, London 1777 and Guillaume-Thomas Raynal: *Histoire philosophique et politique des établissements et du commerce des Européens dans les deux Indes*, Amsterdam 1770. To the Spanish, these works engendered a *leyenda negra* ("black legend", a term popularized by the historian Julián Juderías in the early 20th century) about Spanish rule, which was now to be counteracted using the evidence of the archival documents. See the new edition by Julián Juderías: *La leyenda negra: Estudios acarea del concepto de España en el extranjero*, Junta de Castilla y León: Valladolid 2003.

9 See also González García: *Discovering the Americas*, op. cit., pp. 32–34.

10 See the overview in Mariano Delgado: *Das spanische Jahrhundert (1492–1659). Politik – Religion – Wirtschaft – Kultur,* Wissenschaftliche Buchgesellschaft: Darmstadt 2016.

11 For background information on Spanish expansion, administration and cultures of knowledge see the comprehensive account by Arndt Brendecke: *Imperium und Empirie. Funktionen des Wissens in der spanischen Kolonialherrschaft,* Böhlau Verlag: Cologne/Weimar/Vienna 2009.

12 On this, see the inventory lists, beginning in 1480, in de la Peña y Cámara: *Archivo General de Indias de Sevilla,* op. cit., pp. 80–145.

13 See the observations on the emergence of the new empire after the victory over the Muslims at Granada on 2 January 1492 and the significance of language for this empire in Nebrija's prologue: Axel Schönberger (ed.): *Die Gramática de la lengua castellana des Antonio de Nebrija. Kastilischer Text und kommentierte deutsche Übersetzung der ersten spanischen Grammatik aus dem Jahre 1492, Teil 1,* Valentia: Frankfurt am Main 2016, pp. 35–37 with commentary on pp. 44–47.

14 Marc-André Grebe: *Akten, Archive, Absolutismus? Das Kronarchiv von Simancas im Herrschaftsgefüge der spanischen Habsburger (1540–1598),* Vervuert: Frankfurt am Main 2012.

15 On the archival practice of the period and the circulation of knowledge beyond the archives see Arndt Brendecke: "›Arca, archivillo, archivo‹: the keeping, use and status of historical documents about the Spanish *Conquista*", in: *Archival Science* 10 (3/2010), pp. 267–283.

16 Bernhard Siegert: *Passagiere und Papiere. Schreibakte auf der Schwelle zwischen Spanien und Amerika,* Wilhelm Fink Verlag: München/Zürich 2006.

17 Jacques Derrida: *Archive Fever: A Freudian Impression,* transl. by Eric Prenowitz, University of Chicago Press: Chicago 1996.

18 Juan Bautista Muñoz: *Historia del Nuevo-Mundo,* Vol. 1, Ibarra: Madrid 1793.

19 John H. Elliott: *The Old World and the New: 1492–1650,* Cambridge University Press: Cambridge 1970.

20 All quotations are taken from ibid., p. 9f., quotation from Adam Smith ibid., p. 1.

21 See in detail Toby Lester: *The Fourth Part of the World: The Race to the Ends of the Earth, and the Epic Story of the Map That Gave America Its Name,* Free Press: New York 2009.

22 Quoted from: Matthias Meyn et al. (eds.): *Die großen Entdeckungen,* C.H. Beck: Munich 1984 (= *Dokumente zur Geschichte der europäischen Expansion* 2), p. 17.

23 Lester: *The Fourth Part of the World,* op. cit., p. 23f.; cf. Ralph Waldo Emerson: *The Collected Works of Ralph Waldo Emerson. Volume V: English traits,* ed. by Douglas Emory Wilson, Harvard University Press: Cambridge, MA 1994, p. 86.

24 Ibid., p. 21.

25 Ibid., p. 23.

26 Ibid., p. 21f.

27 Thomas Schölderle: "Ikonografie der Utopie. Bilderwelten und ihr Symbolgehalt im utopischen Diskurs der Frühen Neuzeit", in: *Neue Diskurse der Gelehrtenkultur in der Frühen Neuzeit. Ein Handbuch,* ed. by Herbert Jaumann and Gideon Stiening, De Gruyter: Berlin/Boston 2016, pp. 507–563; idem: *Geschichte der Utopie: eine Einführung,* Böhlau Verlag: Cologne/Weimar/Vienna, 2nd updated edition, 2017.

28 On travelogues, see the methodological and theoretical considerations of Mary C. Fuller: *Voyages in Print. English Travel to America 1576–1624,* Cambridge University Press: Cambridge 1995; idem, *Remembering the Early Modern Voyage. English Narratives in the Age of European Expansion,* Palgrave Macmillan: New York 2008, and Franziska

Hilfiker: *Sea Spots. Perzeption und Repräsentation maritimer Räume im Kontext englischer und niederländischer Explorationen um 1600*, Böhlau Verlag: Cologne/Weimar/Vienna 2019.

29 Robert Poole: *Earthrise. How Man First Saw the Earth*, Yale University Press: New Haven 2008. Cf. Denis Cosgrove: *Apollo's Eye. A Cartographic Genealogy of the Earth in the Western Imagination*, John Hopkins University Press: Baltimore 2003, pp. 257–267.

30 Interviews with the astronauts from the short film *Overview* (USA 2012, directed by Guy Reid) are available at: https://www.youtube.com/watch?v=CHMIfOecrlo.

31 Frank White: *The Overview Effect. Space Exploration and Human Evolution*, Houghton-Mifflin: Boston 1987 (variously reprinted). See further Douglas A. Vakoch (ed.): *Psychology of Space Exploration: Contemporary Research in Historical Perspective*, National Aeronautics and Space Administration: Washington DC 2011 (=The NASA History Series); idem (ed.): *On Orbit and Beyond. Psychological Perspectives on Human Spaceflight*, Springer: Berlin/Heidelberg 2013 (= *Space Technology Library* 29).

32 Cf. short film *Overview*, op. cit.

33 The quotations are taken from the institute's website: https://overviewinstitute.org.

34 The work of Paul Virilio has proven stimulating here, for example his *L'espace critique. Essai*, Christian Bourgois: Paris 1984. See also Denis Cosgrove: *Geography and Vision. Seeing, Imagining and Representing the World*, I.B. Tauris: New York/London 2008.

35 See the exciting attempt at mapping out current developments by Alastair Bonnett: *New Views: The World Mapped Like Never Before: 50 maps of our physical, cultural and political world*, Aurum Press: London 2017.

36 See the contributions in Michael Rathmann (ed.): *Wahrnehmung und Erfassung geographischer Räume in der Antike*, von Zabern: Mainz 2007; on the map and the megacity marked on it, see Karen Radner: *A Short History of Babylon*, Bloomsbury Academic: London 2020, pp. 111–138.

37 See for instance Uvo Hölscher: *Die Odyssee. Epos zwischen Märchen und Roman*, C.H. Beck: Munich, 2nd edition 1989.

38 Martin Zimmermann: *Die seltsamsten Orte der Antike. Gespensterhäuser, Hängende Gärten und die Enden der Welt*, C.H. Beck: Munich 2018.

39 See Raimund Schulz: *Abenteurer der Ferne: Die großen Entdeckungsfahrten und das Weltwissen der Antike*, Klett-Cotta: Stuttgart 2016.

40 Johannes Hahn (ed.): *Alexander in Indien 327–325 v. Chr.*, Jan Thorbecke Verlag: Stuttgart 2000.

41 For explanations of these stories, see Michel Peissel: *The Ants' Gold. The Discovery of the Greek El Dorado in the Himalayas*, Harvill: London 1984; Dominik Berrens: *Soziale Insekten in der Antike. Ein Beitrag zu Naturkonzepten in der griechisch-römischen Kultur*, Vandenhoeck & Ruprecht: Göttingen 2018.

42 Josef Wiesehöfer: "Ein König erschließt und imaginiert sein Imperium: Persische Reichsordnung und persische Reichsbilder zur Zeit Dareios' I. (522–486 v. Chr.)", in: Rathmann (ed.), *Wahrnehmung und Erfassung*, op. cit., pp. 31–40.

43 Herodotus 1.134, in: idem, *The Persian Wars, Volume I: Books 1–2*, trans. by A. D. Godley, Harvard University Press: Cambridge, MA 1920, p. 175.

44 See for instance Burkhard Schnepel/Gunnar Brands/Hanne Schönig (eds.): *Orient – Orientalistik – Orientalismus. Geschichte und Aktualität einer Debatte*, Transcript: Bielefeld 2011.

45 See in depth Mischa Meier: *Geschichte der Völkerwanderung. Europa, Asien und Afrika vom 3. bis zum 8. Jahrhundert n. Chr.*, C.H. Beck: Munich 2019.

46 Wilfried Nippel: "Alte und Neue Welt", in: *Griechen, Barbaren und "Wilde". Alte Geschichte und Sozialanthropologie*, S. Fischer Verlag: Frankfurt am Main 1990, pp. 30–55; on alterity in description see Jürgen Osterhammel: "Von Kolumbus bis Cook. Aspekte einer Literatur- und Erfahrungsgeschichte des überseeischen Reisens", in: *Neue Impulse der Reiseforschung*, ed. by Michael Maurer, Akademie Verlag: Berlin 1999, pp. 97–131.

47 Quoted from the ship's log (Diario 321 and 133) after Stephen Greenblatt: *Marvelous possessions: The Wonder of the New World*, University of Chicago Press: Chicago 1991, p. 75.

48 Matthias Meyn et al.: Der Aufbau der Kolonialreiche, C.H. Beck: Munich 1987, pp. 27–31, quote from p. 29.

49 Léry, Jean de: *History of a Voyage to the Land of Brazil*, translation and introduction by Janet Whatley, University of California Press: Berkeley 1990, pp. lx–lxi; Greenblatt: *Marvelous Possessions*, op. cit., p. 22.

50 Rudolf Simek: *Monster im Mittelalter – Die phantastische Welt der Wundervölker und Fabelwesen*, Böhlau Verlag: Cologne/Weimar/Vienna 2015. On the evaluation of monsters in the academies of natural sciences see also Fabian Krämer: "*Richtig* beobachten: Zum zwiespältigen Verhältnis der *Academia Naturae Curiosorum* zu den Monstren", in: *Acta Historica Leopoldina* 65 (2016), pp. 109–130.

51 Chet van Duzer: *Sea monsters on medieval and Renaissance maps*, The British Library: London 2013. See also the transformation effected in scientific engagement with monsters by the consideration of empirical evidence as outlined in Fabian Krämer: *Ein Zentaur in London. Lektüre und Beobachtung in der frühneuzeitlichen Naturbeobachtung*, Didymos-Verlag: Affalterbach 2014.

52 See now the introduction and commentary in: Theodor de Bry: *America. The Complete Plates 1590–1602*, ed. by Michiel van Groesen and Larry E. Tise: Taschen Verlag: Cologne 2019.

53 Elliott: *The Old World and the New*, op. cit., p. 23, also for the next quotation.

54 Greenblatt: *Marvelous Possessions*, op. cit., p. 22f.

55 Manuel Kohlert: *Ideale Balance. Die politische Ökonomie der Emotionen während der spanischen Expansion*, Campus Verlag: Frankfurt/New York 2019, pp. 129–148 (on the dynamics of greed); Stefan Rinke: *Conquistadoren und Azteken. Cortés und die Eroberung Mexikos*, C.H. Beck: Munich 2019.

56 For background and additional notes, see Neil Coffee: *Gift and Gain. How Money Transformed Ancient Rome*, Oxford University Press: Oxford 2017.

57 Quoted from: Reinhard Wendt, "Seit 1492: Begegnung der Kulturen", in: *Frühe Neuzeit*, ed. by Anette Völker-Rasor, Oldenbourg Verlag: Munich 2000, pp. 69–86, here p. 82.

58 Quoted from Kohlert: *Ideale Balance*, op. cit., p. 140.

59 Martin Zimmermann: "Der Troianische Krieg in der Legitimation vom archaischen Griechenland bis zur Türkei der Gegenwart", in: *Der Krieg in den Gründungsmythen europäischer Nationen und der USA*, ed. by Nikolaus Buschmann and Dieter Langewiesche: Campus Verlag: Frankfurt/New York 2004, pp. 398–418.

60 On the political structure of the Mediterranean during these decades, see David Abulafia: *The Great Sea. A Human History of the Mediterranean*, Oxford University Press: Oxford 2011, pp. 428–451.

61 See Stefanie Fricke: *Narrating the Self, Narrating the Other: British Captivity Narratives of the Long Eighteenth Century*, WVT: Trier 2020 [in print].

62 Quoted from Christian Jostmann: *Magellan oder Die erste Umsegelung der Erde*, C.H. Beck: Munich, 3rd edition 2020, p. 65.

63 Beatriz Pastor Bodmer: *The Armature of Conquest. Spanish Accounts of the Discovery of America, 1492–1589*, trans. by Lydia Longstreth Hunt, Stanford University Press: Stanford 1992; Kohlert: *Ideale Balance*, op. cit., pp. 293–298.

64 On Lorenzo Valla and the period, see Arnold Esch: *Rom. Vom Mittelalter zur Renaissance, 1378–1484*, C.H. Beck: Munich 2016, p. 191f.

65 Silvio A. Bedini: *The Pope's Elephant*, Carcanet: Manchester 1997.

66 Matthias Winner: "Raffael malt einen Elefanten", in: *Mitteilungen des Kunsthistorischen Institutes in Florenz* 11 (2/3, 1964), pp. 71–109.

67 This and the two following quotations are taken from Bedini: *The Pope's Elephant*, op. cit., p. 55f.

68 Ida Östenberg: *Staging the World. Spoils, Captives, and Representations in the Roman Triumphal Procession*, Oxford University Press: Oxford 2009.

69 Winner: "Raffael malt einen Elefanten", op. cit., p. 105f.

70 Ibid., p. 89.

71 Bedini: *The Pope's Elephant*, op. cit., p. 145f.

72 Ibid., op. cit., p. 71.

73 Alberto de la Hera Pérez-Cuesta: "La primera división del océano entre Portugal y Castilla", in: *El tratado de Tordesillas y su época*, Vol. 2., ed. by Luis Antonio Ribot García, Adolfo Carrasco Martínez and Luis Adão da Fonseca, Sociedad V Centenario del Tratado de Tordesillas: Valladolid 1995, pp. 1051–1070. Luis Adão da Fonseca/José Manuel Ruíz Asencio (eds.): *Corpus Documental del Tratado de Tordesillas*, Sociedad V Centenario del Tratado de Tordesillas: Valladolid 1995. See also the excellent summaries in Ute Schneider: "Tordesillas 1494 – Der Beginn einer globalen Weltsicht", in: *Saeculum* 53/54 (1/2, 2003), pp. 39–62; Arndt Brendecke: *Imperium und Empirie*, op. cit., pp. 110–119.

74 Ferdinand Gregorovius: *History of the City of Rome in the Middle Ages*, Vol. 7.1, trans. by Annie Hamilton, Cambridge University Press: Cambridge 2010 [1900], p. 343.

75 Quoted from Eric Williams: *Capitalism and Slavery*, University of North Carolina Press: Chapel Hill 1994, p. 4.

76 Jill Lepore: *These Truths. A History of the United States*, New York: Norton 2018, p. 15.

77 Ute Schneider: *Die Macht der Karten. Eine Geschichte der Kartographie vom Mittelalter bis heute*, Theiss: Darmstadt, 4th revised and updated edition 2018, pp. 94–100.

78 Edward Wilson-Lee: *The Catalogue of Shipwrecked Books. Young Columbus and the Quest for a Universal Library*, William Collins: London 2018, on Badajoz esp. pp. 242–252.

79 The first quotation is taken from Anna-Dorothee von den Brincken: "Mappa mundi und Chronographia. Studien zur *imago mundi* des abendländischen Mittelalters", in: *Deutsches Archiv zur Erforschung des Mittelalters* 24, (1968), pp. 118–186, here p. 119; the second from Brendecke: *Imperium und Empirie*, op. cit., p. 97; see also Jerry Brotton: "Terrestrial Globalism: Mapping the Globe in Early Modern Europe", in: *Mappings*, ed. by Denis Cosgrove, Reaktion Books: London 1999, pp. 71–89.

80 Quoted after Brendecke: *Imperium und Empirie*, op. cit., p. 114.

81 Reinhard Wendt: *Vom Kolonialismus zur Globalisierung. Europa und die Welt seit 1500*, Schöningh: Paderborn/Munich/Vienna/Zurich 2007.

82 The first quotation from Columbus is translated from Consuelo Varela (ed.): *Christóbal Colón. Textos y documentos completes*, Alianza Ed.: Madrid 1997, p. 376f. The second is taken from Greenblatt: *Marvelous Possessions*, op. cit., p. 78.

83 Philip E. Steinberg: "Lines of Division, Lines of Connection: Stewardship in the World Ocean", in: *Geographical Review* 89 (2/1999), pp. 254–264.

84 Brendecke: *Imperium und Empire*, op. cit., p. 123.

85 Lester: *The Fourth Part of the World*, op. cit., p. 397f.

86 See Mariano Cuesta Domingo: "El Tratado de Tordesillas y la cartografía en la época de los Reyes Católicos", in: *El Tratado de Tordesillas en la cartografía histórica*, ed. by Juan Vernet and Jesús Varela Marcos, Sociedad V Centenario del Tratado de Tordesillas: Valladolid 1994, pp. 53–84.

87 Schneider: "*Tordesillas 1494*", op. cit. See also Brotton: "Terrestrial Globalism", op. cit. and Cosgrove, *Apollo's Eye*, op. cit., p. 11f. (on Tordesillas) as well as pp. 79–101; idem: *Geography and Vision*, op. cit.

88 The beginning of the sermon given on the 4th of Advent 1517 is quoted from Meyn et al.: *Der Aufbau der Kolonialreiche*, op. cit., pp. 489–497, here p. 493.

89 See Brendecke: *Imperium und Empire*, op. cit., pp. 34–37.

90 See for instance Friedrich Edelmayer: "Hispanoamerika im 16. Jahrhundert", in: *Die Neue Welt. Süd– und Nordamerika in ihrer kolonialen Epoche*, ed. by F. Edelmayer/Margarete Grandner/Bernd Hausberger, Promedia: Vienna 2001, pp. 61–82, esp. pp. 70–73.

91 Quoted after Lepore: *These Truths*, op. cit., p. 20 (from Alfred W. Crosby, *Ecological Imperialism: Biological Expansion of Europe, 900–1900*, Cambridge University Press: Cambridge 1986, p. 215).

92 Aristotle, *Politics*, 1.1254 a–b, translated by H. Rackham, Harvard University Press: Cambridge, MA 1932, pp. 16–23.

93 Quoted after Meyn et al.: *Der Aufbau der Kolonialreiche*, op. cit., pp. 489–497, here p. 494.

94 Quoted after Martin Neumann: *Las Casas. Die unglaubliche Geschichte von der Entdeckung der Neuen Welt*, Herder: Freiburg 1990, p. 75.

95 Quoted after Meyn et al.: *Der Aufbau der Kolonialreiche*, op. cit., p. 490.

96 Lepore: *These Truths*, op. cit., p. 22; Kohlert: *Ideale Balance*, op. cit., pp. 189–213.

97 Francisco de Vitoria: *De Indis et de iure belli reflectiones*, ed. by Ernest Nys, trans. by John Pawley Bate, Carnegie Institute: Washington 1917, pp. 115–187.

98 Ibid., p. 119.

99 Ibid., esp. pp. 129–134; quotations from p. 120 and p. 131.

100 Ibid., pp. 135–137, 144–149; quotation from p. 143.

101 Ibid., quotations from p. 127f.

102 Mariano Delgado: *A Stumbling Block: Bartolome de Las Casas as Defender of the Indians*, trans. by Martha M. Matesich, ATF Theology: Adelaide 2019.

103 Lepore: *These Truths*, op. cit., p. 30.

104 Bernd Roeck: *Der Morgen der Welt. Geschichte der Renaissance*, C.H. Beck: Munich 2017, p. 589.

105 Lepore: *These Truths*, op. cit., p. 10.

106 Theodor de Bry: *America*, op. cit.

107 Translated from Bartolomé de Las Casas, *Werkauswahl*, ed. by Mariano Delgado, Vol. 2: *Historische und ethnographische Schriften*, Schöningh: Paderborn/Munich/Vienna/Zurich 1995, p. 71.

108 See generally Bruno Rech, "Zum Nachleben der Antike im spanischen Überseeimperium. Der Einfluss antiker Schriftsteller auf die *Historia General y Natural de las Indias* des Gonzalo Fernández de Oviedo (1478–1557)", in: *Spanische Forschungen der Görres-Gesellschaft* 31 (1984), pp. 181–244; idem, "Bartolomé de Las Casas und die Antike",

in: *Humanismus und Neue Welt*, ed. by Wolfgang Reinhard, VCH: Weinheim 1987 (= Acta Humaniora), p. 167–197; David A. Lupher: *Romans in a New World: Classical Models in Sixteenth-century Spanish America*, University of Michigan Press: Ann Arbor 2006.

109 Martin Zimmermann: *Gewalt – Die dunkle Seite der Antike*, DVA: Munich 2013, p. 371f.

110 Nippel: *Griechen, Barbaren und "Wilde"*, op. cit., p. 54.

111 Michel de Montaigne: "Of Cannibals", in: idem, *Essays of Montaigne*, Vol. 2, trans. by Charles Cotton, revised by William Carew Hazlett, Edwin C. Hill: New York 1910, pp. 189–218, esp. p. 192, 195f.

112 Ibid., p. 206f.

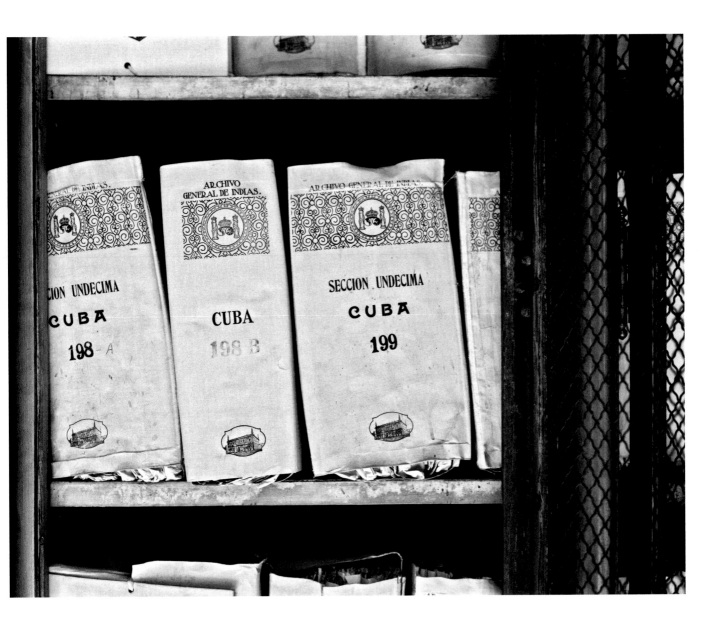

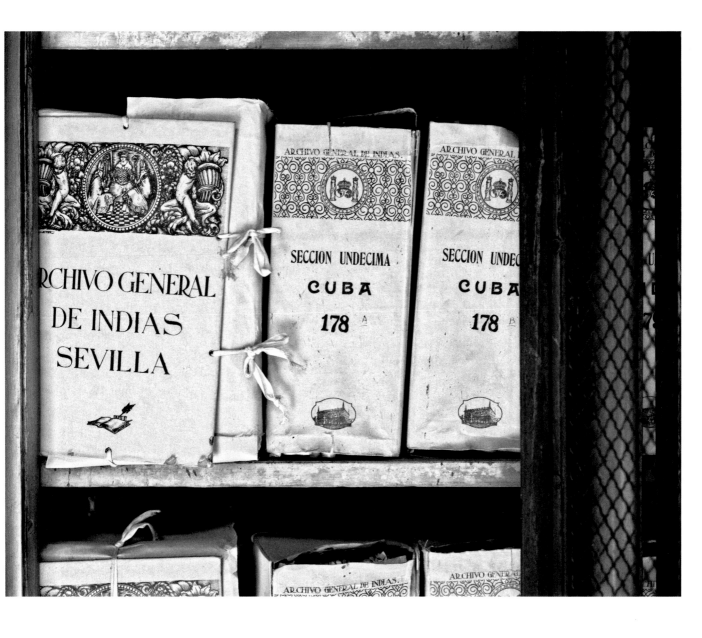

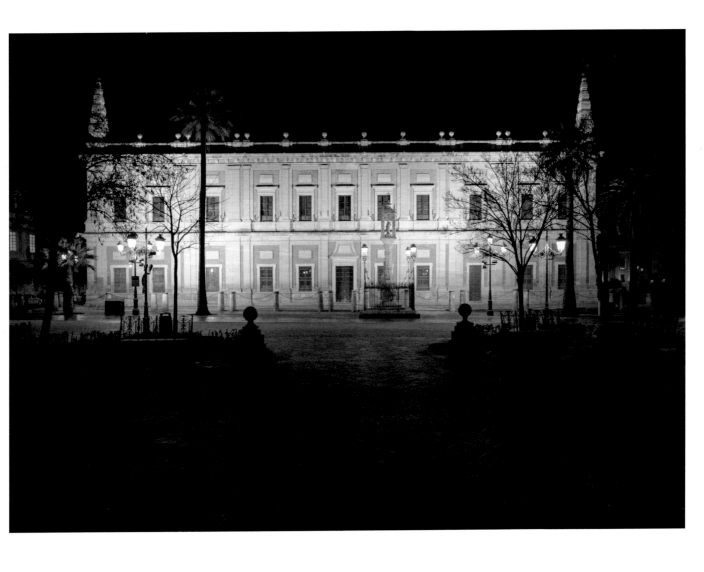